COLD WAR PASTORAL

GREENHAM COMMON

CONTENTS

INTRODUCTION JOHN KIPPIN

Greenham Common is a place whose name resonates for many of us. Certainly, within my lifetime, the name will be synonymous with Cold War politics and a growing awareness of the influence of the United States in decision making relating to our national defence. Above all though, a new kind of organised protest evolved unlike anything seen before, even during the height of the CND protests in the 60s and 70s.

The women at Greenham Common represented a new kind of alliance, one that the authorities found difficult to deal with because the usual direct and forceful physical tactics used in dealing with protestors could not be readily deployed against women. Largely because of this new kind of gender specific and peaceful protest, those politicians and the policies that propagated the Cold War were effectively discredited, and held up to a kind of scrutiny which suggested that a new generation was unwilling to accept the old confrontational approach to world affairs based on threat and counter threat.

The protests at Greenham unleashed many reactionary forces and precipitated an avalanche of misogynistic abuse aimed at the Peace Women, although the serious issues on the agenda were frequently overlooked. Never before has a conflict been so local and simultaneously, global, and involved so many complex issues ostensibly around defence policy but spilling over into issues around class, gender, access and the democratic rights of the individual.

When I came to Greenham in 1998 to photograph the Common, little remained of the United States' airbase. The massive concrete runways were being broken up to make hardcore for new roads and the former barracks were in the process of being converted to a business and enterprise park. I wondered what I could possibly do to make sense of such an undertaking.

During my initial tour of the airbase, I became aware of a flat gravelly landscape relieved by the occasional utilitarian structure which punctuated the mud and gorse. I remember my first sight of the sinister bomber control tower interior, and thinking that should the end come, it would be from a formica clad chipboard console like this one. If not this actual one, maybe another one, set in yet another anonymous distant place. This meagre observation somehow set the tone for the project that was to follow.

My previous work seemed straightforward and contained compared to the complexity of the issues and emotions that I felt then confronted me. The particular moment of my being there seemed arbitrary within the context of the previous

lifetime of the Common, but at the same time, I felt a kind of responsibility towards history. My ambitions became to offer a meditation on and possibly to articulate, in some measure, the relationship between particular histories of the site, my personal memories (as an outsider in every sense) and to reflect these concerns within an arts practice grounded within the representation of the landscape. At the same time, I wanted to consider and to place into context the ethical dilemma of scientifically determined progress with particular regard to its democratic accountability.

This publication contains a number of voices, all of which have approached and enriched the concept of Greenham Common in their own ways through their written contributions. It seemed most important to me that embodied within the core of this enterprise is the need to reflect upon the Common as a place of political focus and activism in historical terms, as Sarah Hipperson, with her extraordinary experience, has done; and to consider this history within the context of the changes being engineered and planned for the development of the new identity of the Common.

Ed Cooper at West Berkshire Council is responsible for many of these initiatives and much of his vision for the future of the Common is reflected in his immensely informative essay, "Swords and Ploughshares". Both Sarah and Ed are able to eloquently communicate the nature of their experiences as individuals who, in different ways, have spent a large part of their creative and political energies on and about Greenham Common. Both lend their authentic voices to this book.

It is important that this publication is seen as an essentially discursive space in which a number of approaches to the subject are allowed to express their priorities and opinions. There is a risk that when anthologising a collection of writings it can sometimes appear somewhat disjointed with the potential for conflicting and overlapping information creating a lack of focus or clarity. At the same time this somewhat *laissez faire* editorial approach permits a wide range of questions to be asked of the reader and viewer and creates a particular space for dialogue. It is an active, and I believe exciting purpose with which to engage.

The images, situated in the centre of the book provide a bridge between the experiential writing of Sarah and Ed and the more distanced and reflective approaches of Liz Wells and Mark Durden. Both Liz and Mark have established considerable reputations within their areas of critical and theoretical commentary and I am most grateful to them for their essential and perceptive contributions. Many of the issues precipitated at Greenham are related to aspects of history and representation through photography and other forms of image making. Liz and Mark are able to reveal this and to place and discuss issues both implicit within and

outwith the work in a broad contextual framework of understanding which is at the same time accessible and informative.

That the project came about at all was due to two people, Ed Cooper, the Commons Project Officer, from West Berkshire Council and Ruth Charity from ArtPoint, the Arts Development Agency based in Oxford. Ed is the major force in the restoration of the Common for future generations and is ever mindful of the need to conserve the evidence of the very specific history of the Common. Ruth has committed herself to the creation and development of the project and has worked tirelessly to ensure that it has come to fruition. I am most grateful to both of them. My part in the proceedings came at a time when both Ed and Ruth had done most of the spadework and hopefully builds on their achievements.

Possibly, with the passage of time, Greenham Common will come to mean something different to our children. Memories are short, particularly painful ones and famously, political ones. As the Common reverts to an area of plateau heathland, in the main, the signs of its previous life as the epicentre of the Cold War in Britain and the protests about nuclear weapons will surely fade away (even though the issues do not!). The Common houses many valuable habitats for plants and wildlife which will now be prioritised and conserved and will provide access to an environment which is a welcome respite from the frantic and frequently careless development relentlessly encountered in the South of England.

Perhaps the contributions to this book will, in the long term, act as a prompt to remind us of a particular chapter in our history, and that future generations, when using the Common to walk or play on, will reflect on what might have been. The photographs, then, operate as a surrogate memory, focusing on a particular reflection of time and place within a period of healing and letting go, whilst we in turn, pause to review our attitudes towards the concept of total war.

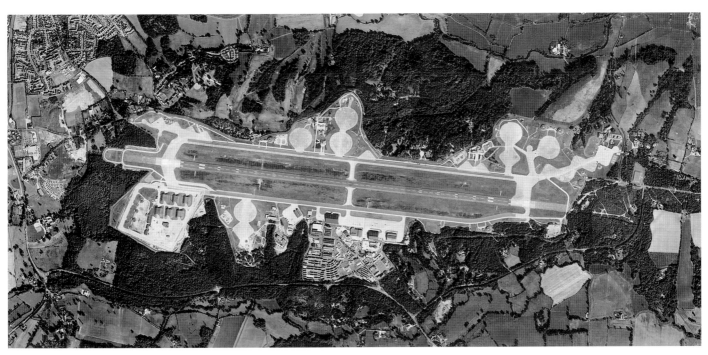

RAF Greenham Common

SWORDS AND PLOUGHSHARES:
THE TRANSFORMATION OF GREENHAM COMMON ED COOPER

THE COMMONS REGAINED

On 8 April 2000 the former airbase at Greenham was opened to the public. The people of Newbury swarmed around the ten foot high airbase perimeter fence that had for so long dominated the northern boundary of Greenham and Crookham Commons, and started to cut the fence down. Small children cut souvenir patches of fence as trophies and there was a genuine air of celebration and relief that finally, after years of planning and work, the Commons could now open and welcome the public.

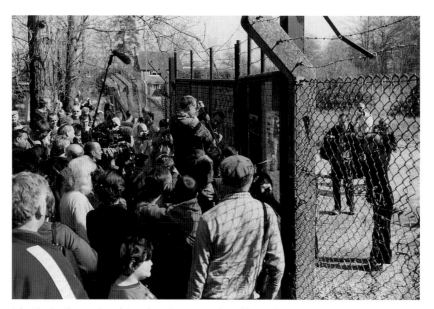

John Kippin, The opening of Greenham Common to the public, April 2001.

Those who had long campaigned for the return of the Commons to public ownership were out in force. Council employees whose role had been to carry out forced evictions of peace campaigners and to police the boundaries of the airbase mixed with ex-peace protesters, commoners and local families. A particularly poignant moment was the sight of Sarah Hipperson, a long term peace campaigner, at Yellow Gate sitting in the sun reminiscing with Keith Ballard, a

John Kippin, The opening of Greenham Common to the public, April 2001.

Countryside Warden for the Council whose prime role during the 80s had been to forcibly evict Peace Woman from the camps around the site. This spirit of healing old wounds and divisions contributed to a day that culminated in a crowd of enthused local people roaming on to the Commons for the first time in fifty years.

The contractors' heavy equipment made short work of the perimeter fence. The speed with which it came down was startling and the effect this had on the Common came as quite a shock. One minute there was a brooding and sinister reminder of the Cold War, the next a vast expanse of open countryside with no obstacles in the way. It is now difficult to remember it cut off by wire and concrete.

THE LARGEST HEATHLAND IN BERKSHIRE

Prior to the construction of the Greenham airbase the Commons were owned by Newbury Borough Council. Ownership was once more transferred to the local community in March 1997, when Newbury District Council acquired the Commons from the Ministry of Defence. The Council, together with local business people, set up a charity, the Greenham Common Trust, which purchased the built area of the airbase for £7 million. The open area of the airfield was sold to the Council for £1. The Trust now runs a thriving business park on a non-profit making basis. All

surplus monies are distributed to local good causes and will provide finances for many local projects for years to come. This visionary mechanism has safeguarded the airfield, allowing the development of the built area and providing a large portion of the funds needed for the restoration of the airfield to open heathland.

> The Common itself was all one; a blanket of gorse and bracken, bramble and heath, woven over a bottom of moss and padded turf, laced with wildflowers and mazed with sheep tracks.
> Victor Bonham Carter, *What Countryman Sir*, 1997

This would have been maintained by grazing, and possibly by burning. When these activities ceased, that most successful of pioneers, birch moved in and much of the Common became dense poor quality woodland to the detriment of the specialist heathland wildlife. Much of this colonising birch, has now been cleared allowing the heather that was slowly being suppressed by shade to again flourish. Last year large areas of this heather appeared to die but it was actually a temporary setback caused by an infestation of heather beetle – a natural and cyclical event that we have also helped to conserve. The heather is now slowly recovering with green shoots appearing at the base of the seemingly dead plants. The Commons cover 500 hectres, about 1,200 acres, and as such represent an opportunity for conservation on a large scale. The range of habitats present is eloquently described in *Mates Illustrated Guide,* published in 1906:

> On this land, whose agricultural value failed to excite the cupidity of our ancestors, the naturalist may roam at will in the pursuit of that particular branch of Natural History to which he is inclined and will find considerable variety of entertainment in the way the wildflowers, insects, etc. on the gravelly heather covered tops, boggy valleys or gullies, or the borders shaded by woods.

Ironically the use of the Commons by the military conserved a crucial element of this diversity – the open heath. Firstly the Ministry of Defence and then the Unites States Air Force, intensively mowed the areas between the runways keeping scrub at bay, thereby allowing heath and meadow to flourish.

Much of the Ministry of Defence work to the base was destructive – the infilling of valley mires at the heads of the gullies that once snaked right up to the apex of

the heathland plateau, the covering of vast extents of heathland in concrete, buildings and tarmac. Nevertheless, the mowing actually produced a unique mix of grassland and heathland containing rare heathland species alongside wildflowers, such as the green winged orchid which is not normally associated with heathland.

The Common is now regionally important for its wildlife and surprisingly the military intervention is one of the reasons for this. Thanks to this intensive mowing and the area of bare ground it created and maintained, tiny annual species such as small cudweed, heath cudweed, annual knawel, fine leaved sandwort and upright chickweed survive. The rare parasitic species dodder creates bare brown patches in the grassland where it has killed off its host grassland plants. A possibly even more direct result of military activity is the presence of dense silky bent, a grass normally found in East Anglia. This is not found anywhere else in Berkshire and it may have arrived by plane from airfields in or near the Brecklands.

The Commons were requisitioned in 1941 by the Ministry of Defence and in 1944, it was from Greenham that, as 131 aircraft and 50 gliders prepared for D Day, President Eisenhower made his famous "the eyes of the world are upon you. The hopes and prayers of liberty-living people everywhere march with you" speech. The activity on the Commons at this time is quite astonishing. Aerial photographs show the entire area completely covered in aeroplanes, tents, storage huts and vehicles. Other commons in the area and Newbury Racecourse were similarly used.

This intensive use of the Commons by the military must have produced a landscape of bare compacted gravels. That this area has now recovered, without any specific management for conservation purposes, to become a site with a rich ground flora is testament to the enormous and perhaps unrecognised powers of recovery by nature. It gives us hope and encouragement for the development of the 100 hectres of bare gravel we now have on the site after the removal of the concrete runways, airbase fuel system and buildings.

CONCRETE AND AVIATION FUEL

The demolition and removal of the longest runway in Europe has been a task of Herculean proportions. For five years Greenham has been one of the largest quarries in Berkshire as over 1 million tonnes of concrete and asphalt was broken up, crushed and piled in vast mountains waiting to be taken off site and re-used. Much of this material helped to build the other symbol of Newbury synonomous with protest, the Newbury bypass.

For years Greenham rang to the metallic sound of large peckers attached to diggers hydraulically chiselling away at the concrete. The 3.6 kilometre central runway turned into an impenetrable jumble of concrete blocks stretching into the distance. That this could then be collected and crushed into a useful building aggregate, known as Type 1 material, was inconceivable to the layman.

The concrete crushing provided a considerable income for the Council, which helped to offset the costs of dealing with the massive airbase fuel system. This consisted of a series of twenty-one petroleum oil lubricant fuel stations dotted around the perimeter of the vast concrete aircraft turning circles. These fuel stations were connected via pipelines, to the National Strategic Fuel Line, which entered the airbase at its eastern end. These fuel tanks had a combined capacity for an extraordinary 8 million gallons of fuel. The Ministry of Defence has retained ownership of the valve chamber at the eastern entrance to the airbase – thereby allowing them to re-connect to the fuel line in the future?

It soon became apparent that this system had leaked. Every fuel station was surrounded by large quantities of gravels polluted with aviation fuel. Many of the tanks were left by the Ministry of Defence with a mixture of fuel and water in them. This meant that 1.5 million gallons of dirty liquid had to be dealt with. The initial thoughts were to tanker this off the site and deal with it elsewhere, but after much searching a company was found who could filter the liquid on the site, which avoided exporting the problem elsewhere. On removal, the reason for the pollution was discovered – some of the older fuel tanks had holes in them. The ground around these tanks was soaked in fuel. Fuel had also migrated through the gravels and sand lining the pipelines necessitating the excavation of trenches across the Common. The Americans had lived up to their reputation for profligacy with fuel. Boreholes and watercourses leading from Greenham, 170 of them, were and still are, sampled and tested every two months to monitor the quality of the ground water.

The options for cleaning up this vast quantity, approximately 200,000 cubic metres, of polluted gravel were limited. Again, removing all this material to a landfill site and exporting the problem elsewhere, with the associated large numbers of lorries on the road, was avoided by bioremediating the gravels on site. This process relies on microbes present in the gravels to break down the hydrocarbons. The gravels are excavated and regularly aerated by turning with a digger. This allows oxygen to reach the microbes and increases the temperature of the gravels allowing microbial activity to rise and to breakdown the hydrocarbons. During the summer the gravels can be cleaned and either spread on the runways or returned to the holes from which they came.

To the north east of Crookham Common lies a large artificially levelled flat plateau of land that was a highly developed part of the airbase containing many fuels stations and vast concrete turning areas for planes. Having broken up the concrete, removed all the fuel stations, excavated the associated pollution and dug up all the pipelines, we were left with a bleak wasteland. A controversial scheme to relandscape this area by removing 600,000 cubic metres of gravel is now underway. The revised land form will contain shallow valleys and wetlands that will help to replace the valley mires that used to be present at the heads of the gullies elsewhere on site prior to the airbase development. This scheme together with proposals for a new visitors' centre prompted the formation of the Burys Bank Road Action Group who felt that too much work was going on and that visitors to the Common should not be encouraged. Changes on this scale will always draw protest. Fortunately the silent majority are often in favour.

WILDLIFE RECOLONISES

Many of the petroleum oil lubricant station excavations are now left as water features on the Common, and are already developing as wildlife areas. Vegetation such as soft rush, reed mace and others are colonising the fringes and wading birds, such as Redshank, Ringed Plover and Lapwing, are using the bare gravels around the ponds to breed. In time, the Common will become a haven for dragonflies and other wildlife associated with acidic ponds.

The plateau of the airbase is basically flat, providing, on a good day, vast sky-scapes with clouds scudding down the runways, or, on a bad day, an exposed bleak wet site with driving rain and biting winds. Within this landscape we have attempted to ensure that the bare gravels are not entirely flat. A prerequisite of wildlife conservation is the diversity of habitats. Small changes in hydrology, aspect, soil type, and fertility can provide niches for specialist plants and animals to survive. Burrowing insects such as the banded sand wasp, green tiger beetle and the minotaur beetle will use warm south facing gravel banks and disturbed ground to nest, adders will bask in sheltered areas, cross leaved heather will thrive in slightly wetter areas and mosses and lichens will colonise open gravels.

Parts of the Common look like a golf course with small humps and hollows. This is deliberate and should add greatly to the diversity of wildlife on the Common. In particular the Common has surprised us by the number of ponds that have developed on the plateau. Gravels are normally very free draining, but it appears

that the silt and clay content of the gravels on Greenham ensures that the base of hollows and indentions in the land seal themselves and hold water. These ponds, many of which will be ephemeral, have the potential to greatly increase the range of wildlife present on the Common. Every year, in November/December when heather seeds are viable and about to fall from the plants, an area of heathland is mowed and the cuttings are foraged. The cut material, including the precious heather seed, is then spread upon the bare gravel areas. Two years later, heather seedlings can be found growing on previously barren gravel.

WORKING COMMON LAND

Greenham and Crookham Common have always been valued by the local community. When the airbase was re-requisitioned by the military at the start of the Cold War, 10,330 people signed a petition to save their Commons. At this time a resolution passed at a protest meeting stated:

> The loss now and for ever, of ancient common lands and liberties would be
> a disaster: these are for us essential parts of that peaceful way of life for the
> protection of which the Defence programme is being undertaken.

Prior to the Second World War the Commons were regularly used as a picnic destination by the people of Newbury. A lone house, The Ark, on the road to Kingsclere supplied refreshments for ramblers and one of the earliest inland golf courses was formed at Crookham. Greenham being extremely close to Newbury was the people of Newbury's very own wilderness area allowing an experience of open countryside, large vistas and, in particular, vast open skies similar to moors and mountains situated on much higher ground.

A local protest group, Commons Again, was formed in 1989 to campaign for the return of the Commons to the people. As a form of protest the tradition of beating the bounds between the parishes of Greenham and Crookham was revived, providing a valid excuse for local people to walk across the airbase. The re-stating of this ancient right continues today and every Rogation Sunday local people walk across the Common. Important discoveries are made on the way, Green Winged Orchids are found on the grassland between the runways, Woodlarks are spotted overhead with their particular bobbing soar and lilting song and the gradual progress on the restoration of the airbase is discussed and

commented on. Events such as this will lead to a rediscovery of the cultural associations of a Common as a recreational area and hopefully as a working countryside with commoners grazing livestock and gathering wood and woodworkers, such as the Gundry Brothers, continuing to coppice areas of birch to produce the essential raw material – young birch growth – for besom brooms. There are proposals for annual races on the Common as a celebration of the open spaces now back in public ownership.

An active volunteer group now meets to carry out conservation tasks under the guidance of the Countryside Rangers. A winter hibernation site has been created for bats out of a derelict building previously used by the United States Air Force as a training area for fire-fighting and a snake hibernaculum has been created out of drainage pipes adjacent to a newly crated wetland area. On the last day I attended we removed a plantation of spruce trees that was steadily invading the heath. The increasing use of the Commons by walkers, cyclists and horse riders does threaten the very things that people enjoy; the ground nesting birds are disturbed by dogs, riders and cyclists erode paths, dog shit pollutes the areas adjacent to the car parks and litter can be a problem, but a balance can be struck and the Commons will be secure if they are valued by the local community.

In addition to leisure, it is vital that the Commons once again become a working area. Grazing is the only realistic method of preserving the open nature of the heathland. Without grazing the Common will be invaded by birch until eventually the rare heathland disappears underneath an impenetrable mass of young birch. This happened outside the airbase and only now after five years work clearing scrub is true open heathland re-establishing itself. The wooded perimeter of the Common on the slopes falling away from the plateau provides a contrast to the open heath and grasslands on the top. These fringes are home to the woodcock, nightingale and in nearly all the heathland clearings, the churring of the nightjar can be heard on a summer evening. If one is particularly fortunate this hawk-like bird will silently patrol in low level flight immediately over watchers' heads. On occasion, the wide gape of the bird's mouth can be seen, as it attempts to catch moths and winged insects in flight.

Walking off the plateau through the bordering birch trees it is possible to plunge into one of the many steep sided gulleys that lead off the Common. These are dark dank places with water seeping out of the hillsides where the underlying clay bagshot beds come to the surface and the water, often orange and rusty with iron, stored in the gravels above, seeps out into gravel based streams. The streams

are lined with multi-stemmed alder, once coppiced over forty years ago, and the ground vegetation consists of sphagnum mosses, ferns and rushes. These gullies have an almost primeval feel and they add to the diversity of habitats and wildlife on the Commons.

A REMINDER OF THE PAST

The open heathland is dominated by the former airbase Control Tower and by the six silos, still in Ministry of Defence ownership and included in the Intermediate range Nuclear Forces (INF) Treaty. These silos are low squat, powerful, grass covered garages that were used to house the articulated trucks carrying the 96 nuclear armed Cruise missiles that were on standby at Greenham throughout the 1980s. The silos are in the Ground Attack Missile Area (GAMA) ringed by three layers of military fencing that were once topped by razor wire, patrolled by dogs and overseen by armed guards in towers. It is stated locally that this was the most secure place in the UK and that if a person were to get in between the last layers of fencing they would be shot. This is somewhat suspect given the pictures of the Peace Woman making their presences felt on the top of the silos.

The rapid response silo contains cramped confined living quarters in which a team was on permanent standby in order to be able to drive their launcher out onto the concrete and to fire Cruise missiles within a two minute period. This silo retains the large hydraulic rams that opened and shut the drawbridge like doors, sealing the silos against conventional attack and ensuring that we had the capability to respond to the Russians.

What is particularly striking about GAMA is its scale and visibility given that basically the silos are garages. The Cruise missiles could have been hidden away anywhere on obscure airbases and army depots throughout the country – perhaps they were. Greenham is a statement of intent; the longest runway in Europe manned by 2,000 Americans, six huge silos, 96 Cruise missiles. Imagine what it looked like through the eyes of a Russian satellite. It said, "Look at us, look what we can do, can you match this?" Whether this approach truly worked only time will tell.

The silos are awesome reminders of the folly of the recent past, but my first trip into GAMA was notable for the way the area was being taken over by wildlife. It was a hot day in June and on entering GAMA the noise of the insect life was overpowering. Wandering amongst the gorse, heather and birch, discovering peculiar structures half hidden by vegetation, I felt like some eighteenth century explorer stumbling across the remnants of an ancient civilisation.

Greenham evokes strong emotions in the people of Newbury. Some remember it once was a wild heathland Common to be roamed upon, with the Volunteer Inn and The Arc Teahouse for welcome refreshment, rudely interrupted by the requisitioning of the airbase for the war effort. To others it, and the Americans that came with it, were a necessary part of defending our nation and it should be remembered that for many soldiers Greenham airbase was their last footfall on allied soil. In 1997 when the Council took over the management of the airbase there were deeply held views regarding the Peace Women. Some members of 'The Establishment' and many local people, believed that the Council should have nothing to do with them, and that they should not be, in any way, recognised or commemorated.

These entrenched views were the result of some very personal experiences when the Peace Woman regularly besieged the Council Offices. There was resentment at the cost to the Council of policing the Peace Campaign and a strong dislike of the anarchic methods used by the campaigners. Thankfully, this view has now mellowed and there appears to be a recognition that, love them or hate them, the peace protests were important events that should be remembered. Unfortunately the Peace Women are all considered as one entity when even a superficial read of their literature and web sites reveals that there were, in fact, numerous groups who all had different beliefs and behaved in different manners.

THE FUTURE

Well developed plans to utilise the airbase Control Tower as a centre for interpretation are currently on hold due to lack of finance. The building would have been used as a focal point for a visit to the Commons and would have enabled the unique story of the Common to be told. Without this we are, perhaps, doing a disservice to such an important site, and the lessons to be learnt from the Cold War and Peace Campaigns may not get passed on to the next generation. At present it is planned to retain the silos as a sombre reminder of where we found ourselves in the 1980s and every effort will be made to find the necessary finance for the Control Tower.

Much of the Common is now enclosed in 14 kilometre of stock fencing and cattle are once again using it for grazing. The sight of cattle working their way along the grasslands give the Common a new air of calm, certainty and tranquillity, but even this is stimulating further controversy as complaints are made about whether the animals should be allowed to graze across the road over the Common. Greenham it seems will always be able to make the news and will always stimulate opposing views.

A Local Act promoted by West Berkshire Council, the Greenham Bill, is currently on its tortuous way through Parliament. This will reinstate commoners' rights across the entire Common, establish a Greenham Commission to help manage the Common, enshrine its conservation in statute and protect the land from development in perpetuity.

Heather is now growing where we have spread cuttings on the bare gravels and the process of regenerating heathland is well underway. The poor fertility and bare nature of the soils will ensure that rare herbs and plants have the opportunity to thrive and the Commons will become a richer place for wildlife. The first sign of this is the first recorded sighting of Dartford Warblers on the site, the result of the proper management of gorse on the Common.

Partnership has been, and will be, crucial to the success of this project. English Partnerships helped fund the clean up of the contamination. English Nature have provided funds and advice on the restoration of the heathland. Without their commitment it is unlikely the Commons would ever have been grazed again. The Greenham Trust contribute towards the cost of restoration and the Commons are now entered in the Countryside Stewardship Scheme, administered by the Ministry of Agriculture, Fisheries and Food, which provides annual payments towards the conservation work on the Common. Greenham has a modern history that encapsulates opposing views; local needs *versus* national priorities, peace *versus* war, women *versus* men, conservation *versus* recreation, cattle *versus* cars, visitors *versus* residents. It would be fitting if we were now entering a period of calm so that the Common can return to the rural idyll remembered by Mary Rogers, in her childhood of the early 1900s.

> Greenham for me is the first common: the stretch of heather, gorse, bracken and bramble; and deep down in their roots tormentil, and milkwort and mousewort (one could suck the honey from the tiny pink flowers), lichen and moss....

Perhaps now when the last digger has finished the Common will once again revert to this quiet haven.

WOMENS' PEACE CAMP 1981–2000 SARAH HIPPERSON

A stand can be made against invasion by an army;
no stand can be made against invasion by an idea...
Victor Hugo

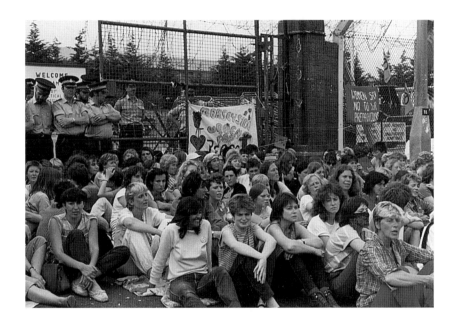

On 12 December 1979, at a secret committee meeting, held at NATO Headquarters, a decision was made to site 96 ground launched Cruise missiles, on Greenham Common. Each of the missiles would carry a nuclear warhead, with the equivalent explosive power of 16 Hiroshima bombs.

These weapons were to be part of a NATO nuclear strategy. This was at a time when the Cold War was at its height. Both Superpowers, the United States of America and the Union of Soviet Socialist Republics, appeared willing to risk nuclear devastation. Both supported the doctrine of Mutual Assured Destruction (MAD).

The horror of Cruise missiles, coupled with the fact that the British public, and their democratic representatives, had not been allowed to know about, let alone to influence, a series of decisions that vitally affected their future – had to be challenged.

On 5 September 1981 a group calling themselves, "Women for Life on Earth", arrived from Cardiff, to Greenham Common. They hoped to start a debate with the

Secretary of State for Defence, Francis Pym – but this didn't happen. On arrival, they delivered a letter to the base Commander, which in essence said, "they believed that the nuclear arms race, constituted the greatest threat ever faced by the human race and the living planet". The Commander distainfully dismissed their overtures and declared: "As far as I'm concerned, you can stay here as long as you like." They did that, and set up the Peace Camp, just outside the Main Gate of RAF Greenham Common. The Camp remained at this location for 19 years!

The signboard just inside the gate announced "HOME OF THE 501st TACTICAL MISSILE WING, UNITED STATES AIRFORCE". Although the Ministry of Defence (MOD) was the owner of the land, and the acting landlord of the base was the RAF; the tenant was the United States Airforce (USAF). The 96 Cruise missiles, which arrived on 14 November 1983, were housed in six hardened silos, and were at all times under the command and control of the USAF.

Not many women had heard of Greenham Common, or knew that it was located in Berkshire, in the heart of the English countryside. However, it was not long before thousands of women were keen to visit, and make their protest against the decision to site Cruise missiles there. Over the years, the activities and gatherings on this land, would ensure that the issue of nuclear weapons in general, and Cruise missiles in particular, would remain at the heart of British politics.

The Camp provided an around the clock location; to observe, and to monitor the activities inside the base, and to disrupt the preparations for the arrival of 'Cruise'. Women were prepared to interrupt any and all military exercises. As soon as the military personnel were spotted wearing radiation suits, gas masks, and carrying guns, women would enter the base to disrupt the activities. When the sirens sounded around 4 AM, to alert the military personnel and the families living outside the base of an imminent nuclear attack, women would immediately scramble out of their tents and sit down on the approach road to the base. Cars and their passengers would be stopped from entering the base, and subsequently from reaching the bunkers.

The USAF Commander was the only one who knew whether the alert was real or an exercise. Mothers with their children arrived in their night clothes and were shocked to find their way being blocked by women sitting on the road. By the time Thames Valley Police arrived to drag the women away, it was all too late for the families to reach the bunkers. These exercises took place regularly until the Commander abandoned them. Women adopted this tactic to emphasise that there would be no survival for anyone in the event of nuclear war.

On 12 December 1982, the third anniversary of the NATO decision, 30,000 women, linking hands, encircled the base – the picture of this powerful action was relayed around the world. Women from every corner of the globe, either visited or sent messages in support of the Peace Camp. The women from the Camp were interviewed by the world's media and called upon to speak at national and international conferences and gatherings. On the fourth anniversary, in 1983, 50,000 women encircled the base, and pulled down parts of the fence. Everyone now knew where Greenham Common was located – it was 'marked' very firmly on the map!

The camp was the platform from which action and pronouncements would be seized upon, as if the women were the authentic voice, and ambassadors, for peace. Flattering though this was, it could be very tiring. No matter what the time of the day, or the weather, women were expected to accommodate all the needs of visitors and the media. This was understandable as there was so much anxiety and fear around, and women were seen as an edifying force.

Maintaining the Camp under the circumstances that women had to live was hard work. The daily routine of gathering wood, collecting water, washing clothes, and preparing food, took up much more time than could be imagined. Discussions, action meetings, court cases, and the daily evictions could drain away energy – however, a good nights sleep would repair the damage. Breakfast around the camp fire was the best time to measure morale, as with the new day came new ideas, and renewed energy. Also, women knew they numbered more than the number of women sitting round the fire, they were affirmed in so many ways; in the support that came in the mail from around the UK and different parts of the world, and by the women who came at weekends, and short stay holidays, in spite of their being harassed by the MOD taking their car numbers, and with the threat of court action. The Camp was more than a place to live in, it sustained women at different levels of life.

The world's media would visit the Camp regularly seeking information on the how's and why's of the protest, while at the same time trying to understand why women left their homes to live in such primitive conditions! Walter Cronkite, the renowned American reporter, visiting the Camp for a televised broadcast, commented, "Looking around here, one could be forgiven for thinking that we were in a Third World country". He was looking at the spartan conditions, and the 'benders' – shelters which were made of pliable tree branches, bent to form an igloo shape, and covered with plastic sheeting They were less tidy than tents, but with much more room inside. Women quickly became adjusted to their new way of living and it also gave them some insight into how women lived in other

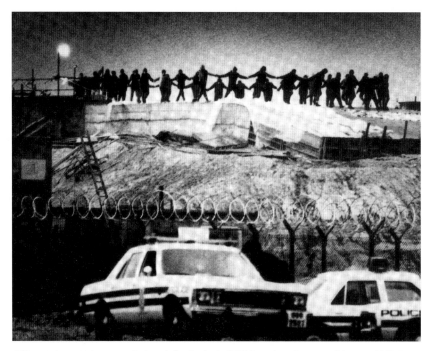

"Women dance at dawn on a Cruise missile silo site in USAF Greenham Common, 1 January 1983."
Photo © Raissa Page. ACME Cards London.

countries. An exchange visit that brought two women from Zimbabwe to stay at the Camp, was very rewarding all round – as the Camp benefited from the rural skills of the visitors.

In March 1983, a High Court Injunction was issued against 21 women who lived at the Camp. Hundreds of women arrived at the court, and spilled out on to the Strand, where an impromptu demonstration in support of the Camp took place. Women, like myself, were willing to go and live at the Camp to replace the injuncted women. They presented affidavits to the High Court, swearing that they regarded the Women's Peace Camp as both a spiritual, and temporal home. When the injunction failed to clear women from the Common, two months later, on 12 May, the Camp was evicted. Women were handled in a violent manner by bailiffs, cars were seized and impounded.

Later this would prove to have been illegal, and the cars had to be returned. In spite of this attempt to break the morale of women and the protest, the Peace Camp continued, and expanded to form camps at all of the other gates around the perimeter fence. Each camp was defined by a colour of the Rainbow. The original Womens' Peace Camp, outside the Main Gate, was known as Yellow Gate.

The taproot of violence in our society today is our intent to use nuclear weapons. Once we have agreed to that, all other evil is minor in comparison. Until we squarely face the question of our consent to use nuclear weapons any hope of large scale improvements of public morality is doomed to failure.

Professor Richard McSorley, S J

When the USAF Cruise missile technicians, arrived on Greenham in 1983, The Chief Training Instructor, Major William Phillips, made public the following statement; "The battle plans are already on tapes in the computer. We don't know what the targets are. We just shoot in the dark. Soon it will be possible for computers to launch nuclear war in three minutes."

On 29 October 1983 about two weeks before the Cruise missiles arrived, 2,000 women, using bolt cutters, cut down five miles of the fence surrounding the base. The action had been carefully planned. Women came from all over the UK to take part in this powerful action. It was intended to send a message to the military, that the fence could not be relied upon to provide security for them and would not prevent women from entering to taking non-violent direct action against the preparations for nuclear war. Of course this meant hundreds of arrests, court cases, and prison sentences to be served, which was an accepted consequence of the Camp's commitment to non-violent direct action.

The Ground Launched Cruise Missile System was composed of a number of vehicles. Each convoy consisted of a flight of 16 missiles, in four Transporter Erector Launchers, two Launch Control Centres, a recovery vehicle, security trucks, and a 'human requirements vehicle' accompanied by 69 US troops. The convoy was expected to leave Greenham Common secretly, after midnight, and to 'melt' into the countryside. As long as there were women living at the Peace Camp it could do neither – each and every convoy would be disrupted. Between 1984 and 1990, the convoy left Greenham Common, for Salisbury Plain, at least once a month, sometimes twice a month, and at times of international tension.

The 'convoy' day would begin early in the morning. The support vehicles, would suddenly emerge through the Main Gate, carrying materials necessary for the Cruise technician's stay on Salisbury Plain. An attempt was made to rush the vehicles past women before they could blockade. The main convoy, would leave after midnight – the exact time would depend on how long women could hold it up. Building a fire on the approach road was an effective way of doing this.

It required hundreds of police officers to get the convoy out and to bring it back after the exercise. They would line part of the A339 trunk road, and the approach road to the base, and were told to turn their backs to it. The senior officer in charge would call out to his men "its only another traffic job". The atmosphere was highly charged. The area was lit up by huge arc lights, the military personnel and their families would gather just inside the base and applaud as the convoy left – as if the exercise was a theatrical performance!

Women would 'take on' the convoy, and mentally prepare themselves for the ordeal – calling on emotional, and spiritual elements to strengthen them. They would face it with chanting, keening, and the cry of "Blood on your hands". The womens' voices could not be drowned out by the sound of the wheels on the road as the heavy vehicles passed. It was a nightmare scenario for everyone – the women, the police, and the Cruise missile technicians who were on their way to practice nuclear war – a scenario that would be repeated, every time the convoy was exercised. A sense of shame pervaded the whole area. The look on the faces, and the silence that followed, told the full story.

When the convoy left the Common, women would track it to Salisbury Plain. Avoiding detection, they would begin a series of non-violent disrupting actions, mainly by entering the exercise area, holding hands, chanting and singing. The exercises had to be stopped while women remained in the area. The military had to wait until the MOD police arrived, to make arrests and remove women, before resuming the exercise. They were taken to a holding area where they would be processed and charged, and bailed to attend court in Devizes. Different women, at different times, would carry out the disruption. Since the convoy stayed out for five to seven days – it was an extremely exhausting time. Whether they had travelled to Salisbury Plain or stayed behind to hold the Camp with very few women, the whole process took its toll.

Over the years, high strategy meetings would be held inside the base – on how to get rid of the Peace Camp. Before the Cruise missile convoy was to begin a full regular programme, scheduled to commence during June 1984, a supreme effort was made by the combined forces of the Ministry of Defence, Thames Valley Police and West Berkshire County Council. A tip off to the Camp indicated that there was a big eviction planned for 1 April 1984, to take advantage of the absence of 15 women from the Camp who were to begin a lengthy trial on that day at Reading Crown Court. A call went out to women advising them of the situation – approximately 200 arrived and caused the eviction to be delayed for three days. On

4 April 1984, at 6 AM, 400 police officers surrounded the benders and tents of sleeping women, in full view of the television cameras, and began the eviction.

Women were 'herded' along the A339, towards the Hampshire boundary, dragging what belongings they could save! The Camp was destroyed by earth moving equipment, and a fence was erected to keep women off the land. By the end of the day, women had re-grouped. Some had set up camp off the Common, on the other side of the A339, and another group of ten women defied the police and remained on the Common, just opposite where the evicted Camp had been. Ostensibly, the eviction was to enable a road widening construction of the A339, for the articulation, and ease of convoy vehicles from the base.

Women had to live with the bare minimum. Fortunately, supporters had supplied the camp with Gortex bags that were designed for outdoor living. The police patrolled the Common and harassed the women night and day to prevent any form of shelter being erected, or fires being lit – it was a deliberate attempt to break the back of the protest. The USAF Military, the MOD Police and police officers from different authorities all collaborated in what they perceived to be, 'the solution to the Greenham problem'. It was a real crisis time for the Womens' Peace Camp. Had it not survived this period, which lasted ten weeks, it may have been the end for this unique protest.

The pressure on the Camp was only relieved when the civil police were taken away to police the Miner's Strike. The womens' response to this particular eviction, finally convinced the 'authorities' that the eviction policy, as a way of ending the protest, wouldn't work. However Newbury District Council's evictions were inflicted daily, and occasionally, more than once during the day during the winter, and eventually became random. They finally ended in 1993.

From 20 to the 30 September 1984 50,000 women camped around the perimeter fence. This was a demonstration inspired by the belief that at least 10 million women, shared the same concern over the threat of nuclear weapons. The theme was 'TEN MILLION WOMEN FOR TEN DAYS'. It was intended as a show of strength – women gathered together in different countries to speak out and take action.

Besides the convoys, evictions, gatherings, and actions, the day to day life of the Camp edged forwards. The seasons effected the attitude of womens' feelings towards living at the Camp; in spring, summer and autumn it could be defined as the perfect way to live, whereas in winter – when it became dark in the late afternoon and was freezing cold, making it impossible to hammer tent spikes into the ground, after yet another eviction – it could be sheer misery.

There was no joy in having to break the ice on the water but before having the first cup of tea of the day, and after several attempts to get the fire going! Sitting out in the rain all day, getting soaked through, and having to pull on the same wet clothes the next morning could test commitment. Each year as winter approached, a meeting would be held to look at how the Camp would cope with, and survive the winter. When it was dark around 4 PM, cooking on an open fire became difficult, the uneven ground could be hazardous without lights. Carrying water across the A339, always difficult, was dangerous in the dark. When March arrived with the lengthening days, it was exhilarating to know that another winter had been coped with, and that spring was on its way.

On 7 January 1985 Newbury District Council's Electoral Officer, held a meeting in the Council Chambers to deal with an objection from Anthony Meyer, a member of a group, calling themselves; Ratepayers Against Greenham Encampments (RAGE). He objected on the grounds that the Womens' Peace Camp could not qualify as a lawful residence, therefore women who lived there were not eligible for inclusion on the Electoral Register. It was quite clear that this was yet another attempt to get rid of the Womens' Peace Camp. At the end of the hearing, a group of women from Yellow Gate, were disenfranchised.

The right for women to vote, won by the Suffragette Movement, was swept aside. After months of legal wrangling through the courts, the case was finally resolved in the Court of Appeal, before the Master of the Rolls, Sir John Donaldson, who delivered his judgement on 1 May 1985.

The judgement established that women could rely on the the Womens' Peace Camp as a residence qualification, and therefore, were entitled to be on the Electoral Register with the right to vote. The final outcome provided women with greater confidence, and security, about living at the Womens' Peace Camp.[1]

On 1 April 1985 the Secretary of State for Defence, Michael Heseltine, made a new set of byelaws for Greenham Common. Among other things, they stated: "The Secretary of State for Defence in exercise of his powers under Part 11 of the Military Lands Act 1892(a) and of all other powers enabling him in that behalf, hereby makes the following byelaws."

In essence, it made anyone found within the base, without authorized permission, guilty of the offence of Criminal Trespass. It was clearly intended to be used to stop the protest. Women responded in their usual way – they took it on. On the stroke of midnight, 1 April, hundreds of women entered the base in order to break the new byelaws – the rest of the night was spent by women being

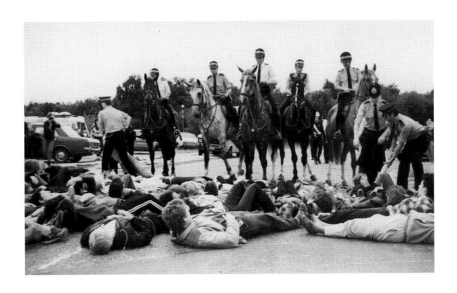

arrested, packed into buses and any available space, and charged with this new offence. Later, hundreds of women were convicted and sent to prison. It is recorded in Hansard that there were 812 cases of trespass recorded between January 1987 and April 1988. Parliament was told "the total number could not be identified without disproportionate effort".

Two women from Yellow Gate Peace Camp appealed against their convictions, and challenged the legality of the byelaws. The case started in June 1986, in Newbury Magistrates Court, and finally ended in the House of Lords, on 12 July 1990. The women won their case, the Law Lords upheld their appeal and the arrests under these byelaws were unlawful. Five Law Lords, on a unanimous judgement, rendered the byelaws invalid and stated: "The draftsman of the byelaws cannot possibly have been in ignorance of the terms and effect of the proviso to section 14 (1) of the Military Lands Act of 1892 and the theory of an inadvertent omission appears the less plausible."

The proviso to section 14 (1) did not allow the Secretary of State for Defence, to make byelaws for Greenham Common that would "take away or prejudicially affect any rights of common".

The House of Lords' judgement quite clearly implied that The Secretary of State for Defence knew that he was acting unlawfully. One of the five Law Lords went further and stated: "It is up to the law-maker to keep within his powers and it is in the public interest that he should take care, in order that the public may be able to rely on the written word as representing the law." [2]

Women were convinced that the Secretary of State for Defence intentionally criminalised women for political reasons. There was no apology or compensation for the women who were criminalised and imprisoned by the use of these byelaws. Following the House of Lords' judgement, there was no censure for those who played a part in the deception – starting with the Secretary of State for Defence, the MOD Police, and the Courts that sentenced women to prison.

The day before the House of Lords' judgement was given, the last Cruise missile convoy was exercised from Greenham Common, on 11 July 1990. Both events were celebrated with champagne.

Cruise missiles were signed away under the Intermediate Nuclear Forces (INF) Treaty on 8 December 1987. The treaty signed by Reagan and Gorbachev eliminated a specific class of weapons, which included; Cruise and Pershing missiles, the SS20s and their successors. These weapons represented less than 4% of the total nuclear armoury; nevertheless, it was a step forward and a great sense of achievement, especially on reading the preamble to the Treaty which states "Conscious that nuclear war would have devastating consequences for all mankind". Women felt vindicated in the stand they had taken, and that their message was at last being understood.

> The law doth punish man or woman
> Who steals the goose from off the Common,
> But lets the greater felon loose,
> Who steals the Common from the goose.
> *anon*, eighteenth century

During the course of the 'Byelaws' case, certain legal shortcomings by the Ministry of Defence were revealed. On 29 April 1988 it was recorded in the House of Commons, Hansard, that the Secretary of State for Defence, in answer to the question "Under what powers RAF Greenham Common was acquired and has been developed by his Department?" answered, "The freehold of Greenham Common had been acquired in 1960 and was subject to the provisions of the Law of Property Act 1925, which lays down that consents are required from the Secretary of State for the Environment, over and above normal planning consultation, before building on land subject to rights of common". The Secretary of State for Defence admitted to Parliament, that, "no consent under the Law of Property Act 1925 had been sought by the MOD" – he added, "Steps therefore

need to be taken to remove a legal obstacle to further construction which could impede this and other work."

The House was told that some building would be required under the INF Treaty. This reply amounted to an admission that everything that had been built inside the base, under the ownership of the MOD, had been built illegally!

The 'legal obstacle' referred to in the answer, was the same 'rights of common' that had rendered the byelaws, made by the Secretary of State for Defence, unlawful – and should have prevented building on Greenham Common. Had the MOD acted within the law the planned removal of the 'legal obstacle' by the MOD, required the extinguishment of the rights of common. This became clear at the beginning of August 1988 when they began the process. After meetings, argument, protest, and legal wrangling, at the end of May 1991, the MOD declared that rights of common on Greenham were extinguished under the Land Clauses Consolidation Act 1845.

The Guardian newspaper had, on 10 and 11 February 1990, reported the MOD interest in developing Greenham Common for commercial use. The article stated: "If housing is ever allowed on it, the MOD, which bought it secretly, will make one of the biggest bonanzas in the annals of privatisation."

In 1993, a "Planning Brief for Greenham Common", was prepared for the MOD with the purpose of, "achieving the disposal of the land on the basis of suitable planning permissions and arrangements or agreements". This, just two years after they claimed to have extinguished commoners' rights – supposedly for the development of premises, needed under the INF Treaty.

Women believed that their ownership of a piece of land on Greenham Common, acquired in 1987 from donations to the Womens' Peace Camp, gave them the legal basis to object to the MOD plans for the development of Greenham Common, and in 1995 began legal action. The County Court was asked to order the Secretary of State for Defence to remove a delineating fence around an area planned for development. There was an admission that permission had not been sought from the Secretary of State for the Environment, as was required under Law of Property Act 1925. The MOD responded with a counter claim that the application should be 'struck out'. The court allowed the case to go ahead as 'interested parties' because of the small piece of land owned by the Camp. The MOD defence argument claimed that – as a result of certain events in 1988/1991, all rights of Common had been compulsory acquired and extinguished. The implication being that the 'legal obstacle' had been removed.

Women were expecting the MOD barrister to present the process and justification by which 'rights of common' had been removed and extinguished on this ancient, twelfth century Common. On 12 December 1996, at the start of the case, the MOD changed their defence argument. They avoided legally testing the process of extinguishment by returning to their earlier position that women did not have the 'locus' on which to bring an action. The judge overruled the earlier decision that had allowed the case to go ahead. The women lost the case – however they were convinced that the court action had been instrumental in preventing the development of Greenham Common for commercial use.

In March 1997, just three months later, the MOD sold the land to the Greenham Common Trust. When the USAF and the ground launched Cruise missiles left Greenham in 1991, there was a sense, for some women, that the work had been completed – but for others this was not so, and the Camp continued. This was the right decision. By 1992 attention had turned to the Atomic Weapons Establishments at Aldermaston and Burghfield, where the warheads for Trident missiles are manufactured and assembled. Women were learning about the Trident convoy, which brought the missiles down from Faslane, for refurbishment. Regular monitoring of Burghfield, would reveal when the convoy was ready to make the return journey back to Faslane, and it would be tracked to RAF Wittering as well as bases in East Anglia. The continuation of non-violent direct action at these other locations caught the military and the police by surprise. On arrest and conviction, the courts were handing out heavier sentences, in an attempt to deter women from taking action at these other bases.

In 1996 the International Court of Justice, on instruction from the United Nations, gave an Advisory Opinion to the question – "Is the threat or use of nuclear weapons in any circumstances permitted under international law." The Court made up of 14 of the world's most eminent judges, produced a lengthy 'advisory opinion'. Although they didn't agree on all matters, there was a unanimous agreement that stated: "A threat or use of force by means of nuclear weapons that is contrary to Article 2, paragraph 4 of the United Nations Charter and that fails to meet all the requirements of Article 51, is unlawful."

Women, using the Advisory Opinion as evidence, and supported by a number of physicians, scientists and international lawyers, mounted a series of legal challenges through the criminal courts, with partial success. The first case was due to be heard in September 1997 – the Crown Prosecution avoided the challenge by withdrawing the charges. In 1998, with the same evidence and set of experts, a

'hung jury' verdict was given. However, there was a retrial, and before it started, the Judge ruled out all references to International Law, and refused to hear evidence from a distinguished Professor of Law who had given evidence to the International Court of Justice. The case was lost. A third attempt reached the High Court on 5 October 2000, a month after the Camp had closed. That case was also lost.

The process of seeking to test the legality of nuclear weapons, through the courts, could not be avoided. The process is as important as the outcome. It calls to account the decision makers, and all who are part of enforcing the decision it is a way of not being encompassed into the decision! In 1998 women began to consider how the Camp would be brought to an end. Looking back over the years of hard work to keep the camp going; the resistance to nuclear weapons, and the consequential time spent in prison, the number of legal challenges made in support of the stand made, and maintained since 1981; women were convinced that the work, and the history of the protest, should be commemorated.

With help from supporters with the necessary skills, plans were submitted to West Berkshire Council in July 1999. A brief history of the Camp, and womens' concept of the 'Site' were also sent with the plans – an extract from this stated:

> We believe that despite the years of conflict between the military occupation and the Womens' Peace Camp, history will record that the resistance by women was governed by a commitment to non-violence. This commitment produced a spiritual energy which brought benefits to the area. We believe this commitment should be commemorated.

On 3 November that same year, at a sub-committee planning meeting, held at West Berkshire Council – approval was given for the plans, for a Commemorative and Historic Site and the erection of sculpture on the land that has been the Womens' Peace Camp since 5 September 1981. There were conditions attached to the approval. These were fulfilled, and permission to build was given on 9 October 2000, a month after the Camp closed.

The design will encompass the four elements: Earth-Air-Fire-Water. A circle of standing stones will surround a sculpture representing fire. Also, a stone and steel spiral sculpture, through which water will flow assisted by a solar panel will indicate continuous resistance to nuclear weapons. A small garden, remembering Helen Thomas, that has been part of the Camp since she was killed on 5 August 1989, will be incorporated into the site. Fund-raising for the site by donations will be the

last 'action' carried out by the Womens' Peace Camp. A collective of women, who gave of their time and commitment to the work over the years, have assumed responsibility for it.

The camp closed on 5 September 2000. The media came to see it end, their numbers testified to the important role that the Womens' Peace Camp played in their reporting of grass roots political activity during the 80s and 90s. There was an acceptance that they also had a need to bring their part of this period to an end, and that they should witness its going. *The Guardian* comment said all that needed to be said: "Their departure brings to an end nineteen years of continuous protest."

EPILOGUE

> We can best help you prevent war not by
> repeating your words and following your methods,
> but by finding new words and creating new methods
> Virgina Woolf

The Womens' Peace Camp on Greenham Common was the right place, and the right time, to put these words into practice. The 'new words and new methods' that women brought to this unique protest caught the authorities off balance, and gave an advantage and strength. It was not a prescribed formula; it grew organically, and was nurtured by different women at different stages of the development of the protest. Women at all stages of life, from different backgrounds of, class, ethnicity, and nationality, brought to the struggle their own unique perceptions, and a determination to effect change. The relaxed outdoors location; the ordinariness of it all was exciting, and gave women a sense of inclusion. Greenham was the one place where it was important to be a woman. The strict adherence to non-violent direct action in the conduct of the protest, and the willingness to accept the consequences, produced a paradigm, that is, at the very least, a pointer to how we can best help prevent war!

NOTES

1. Hipperson – v – Newbury District Electoral Registration Officer (1985), QB 1060.

2. Director of Public Prosecutions – v – Hutchinson (1990), AC 783 in the House of Lords.

COLD WAR PASTORAL

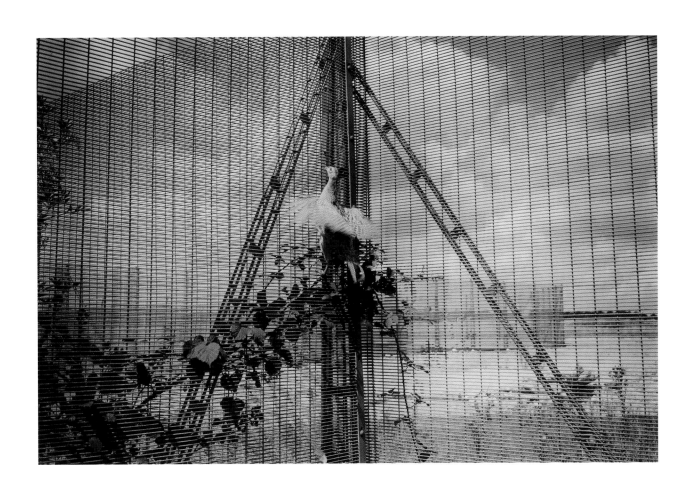

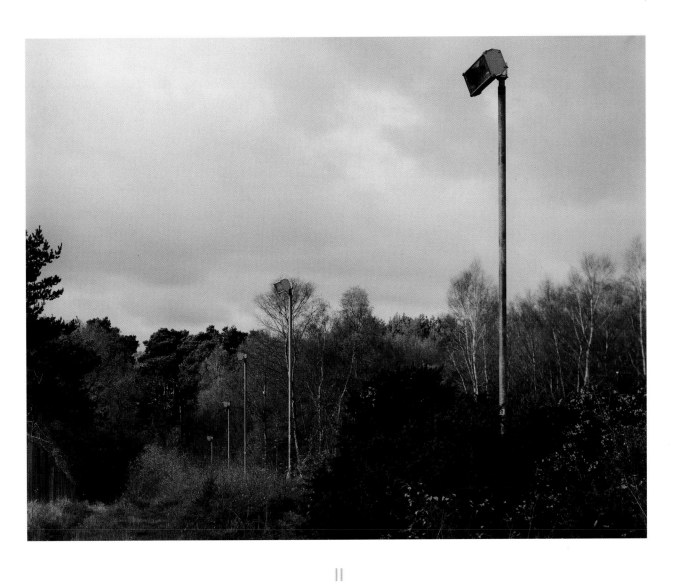

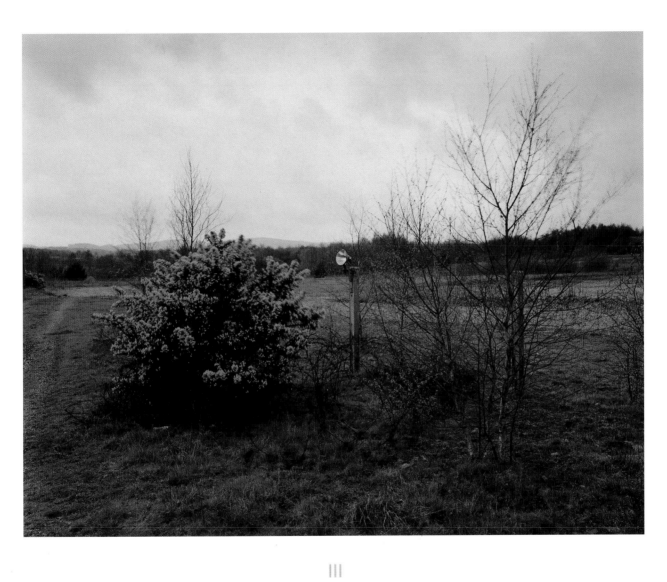

III

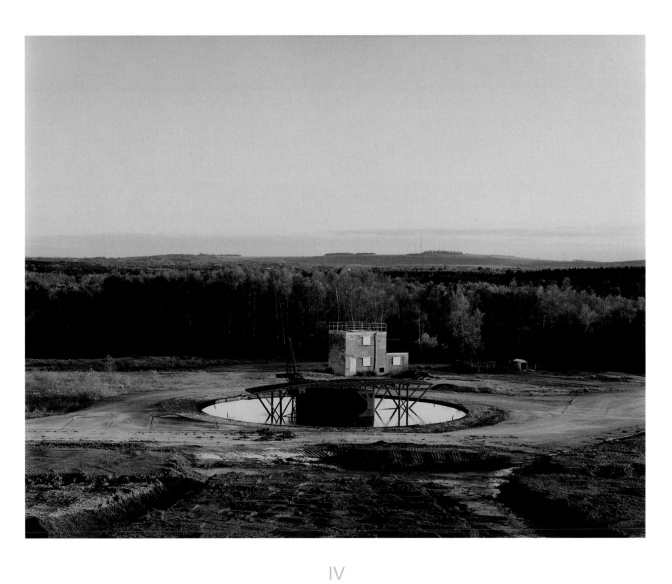

IV

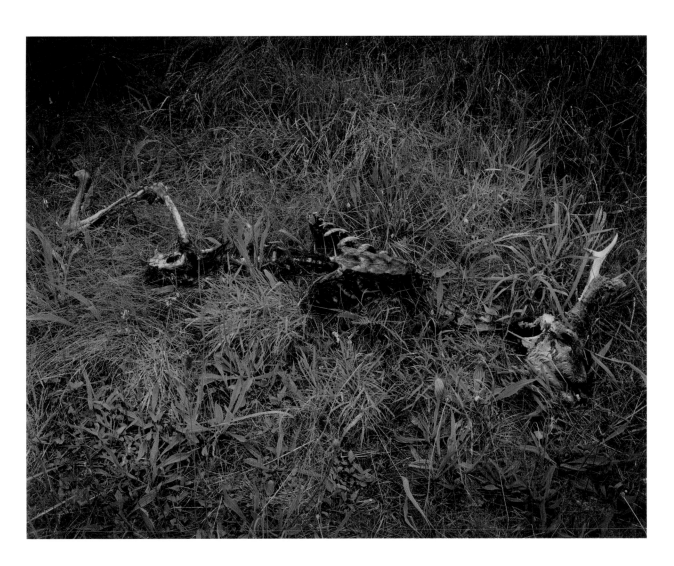

V

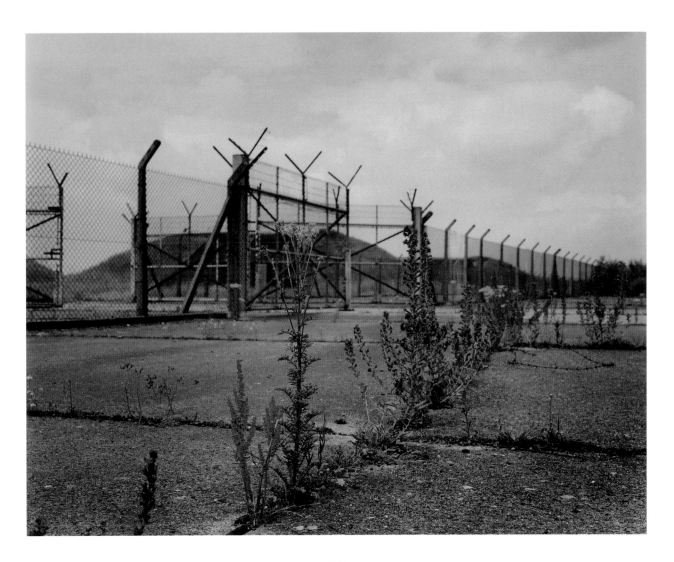

VI

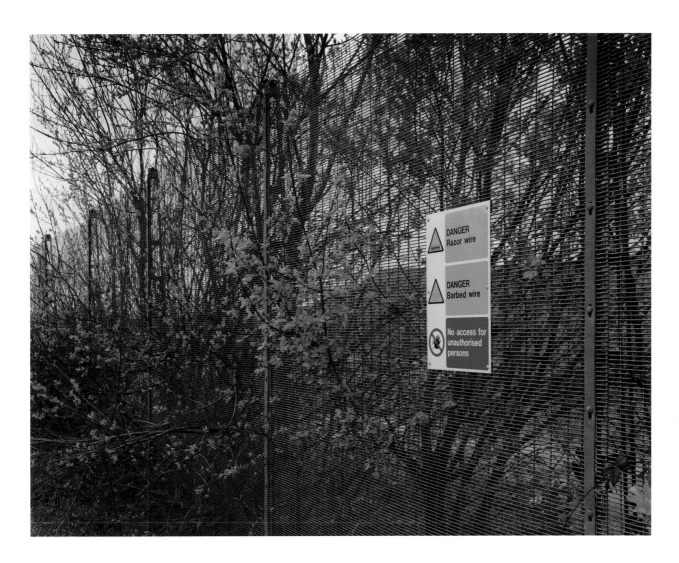

VII

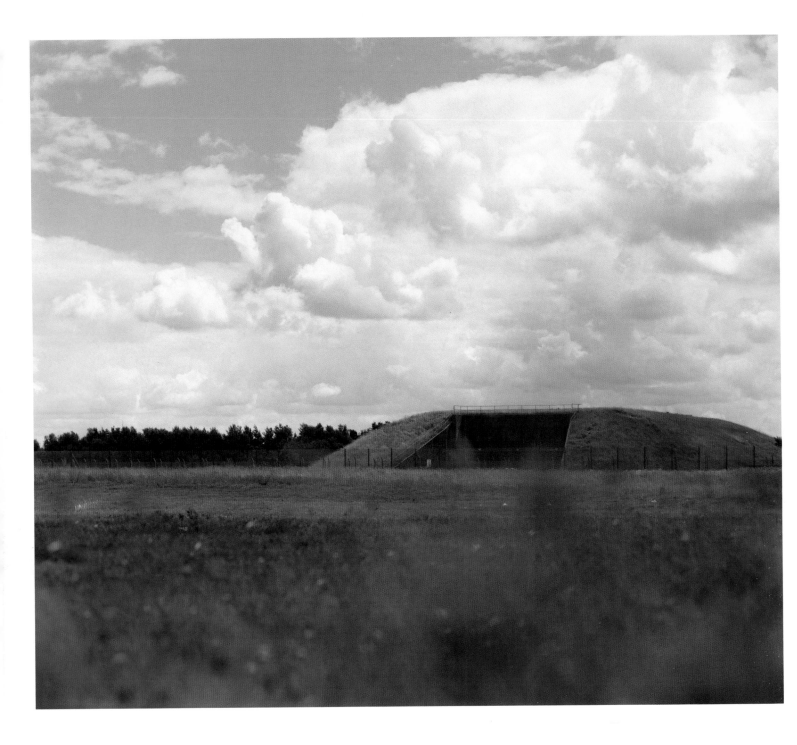

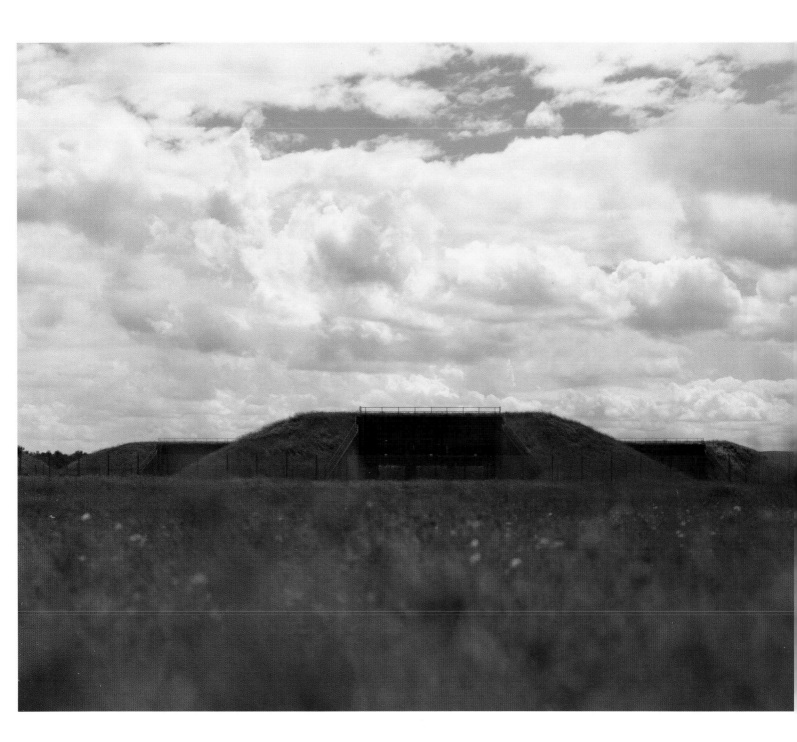

VIII

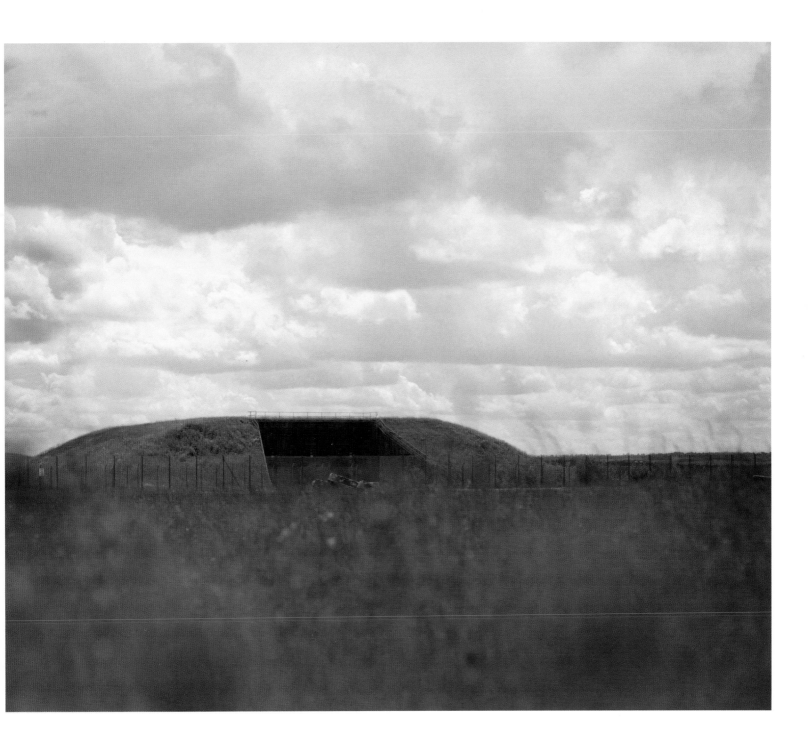

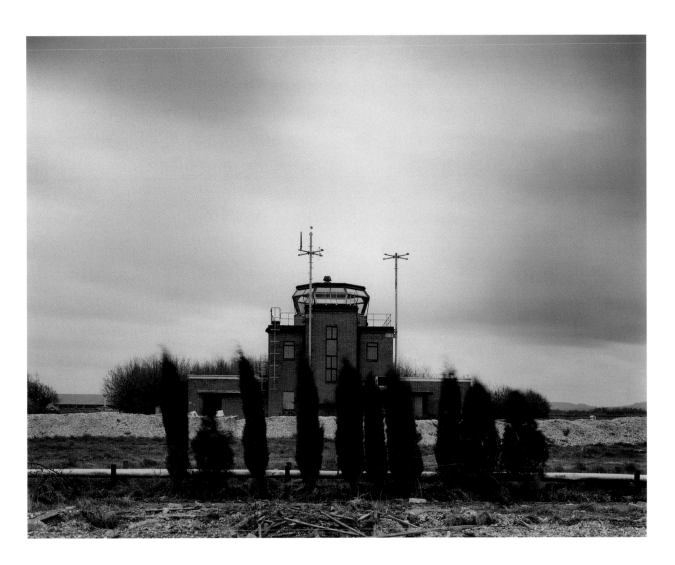

IX

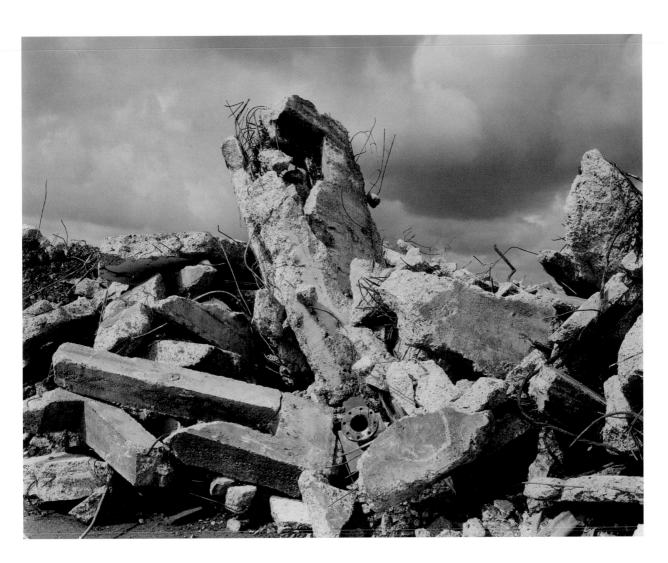

X

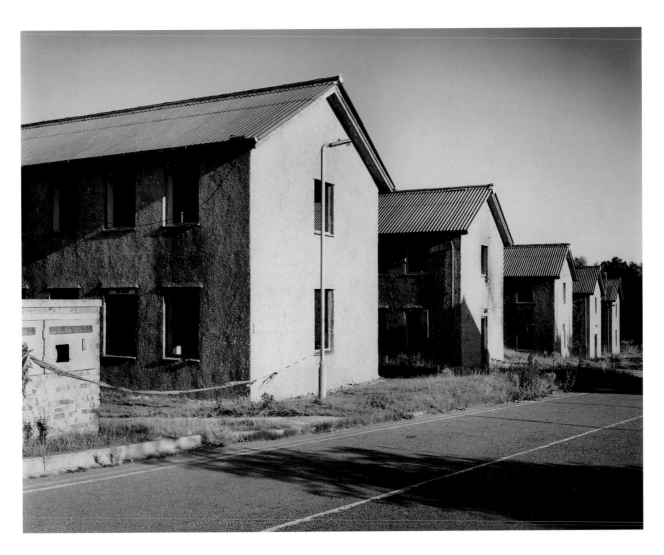

XI

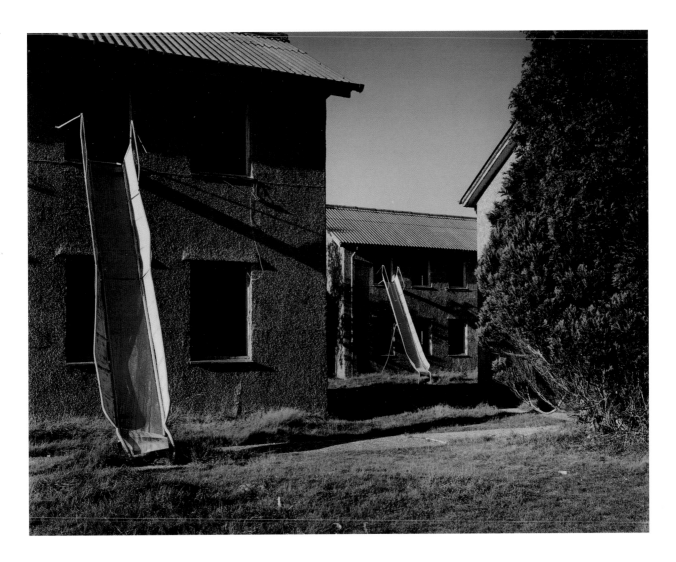

XII

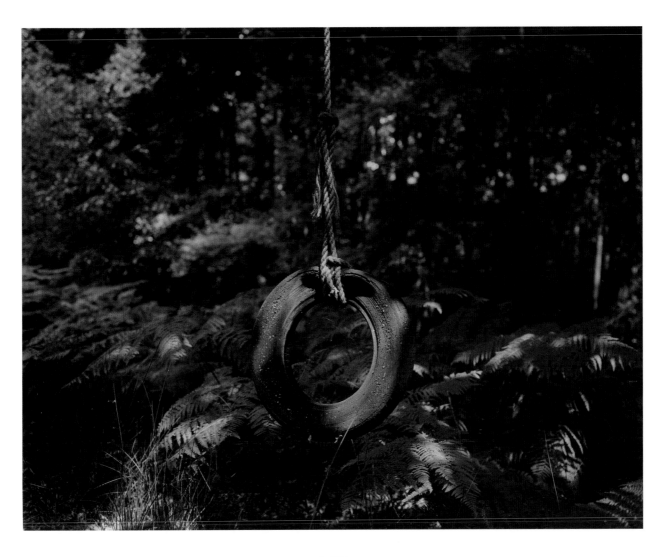

XIII

XIV

XV

XVI

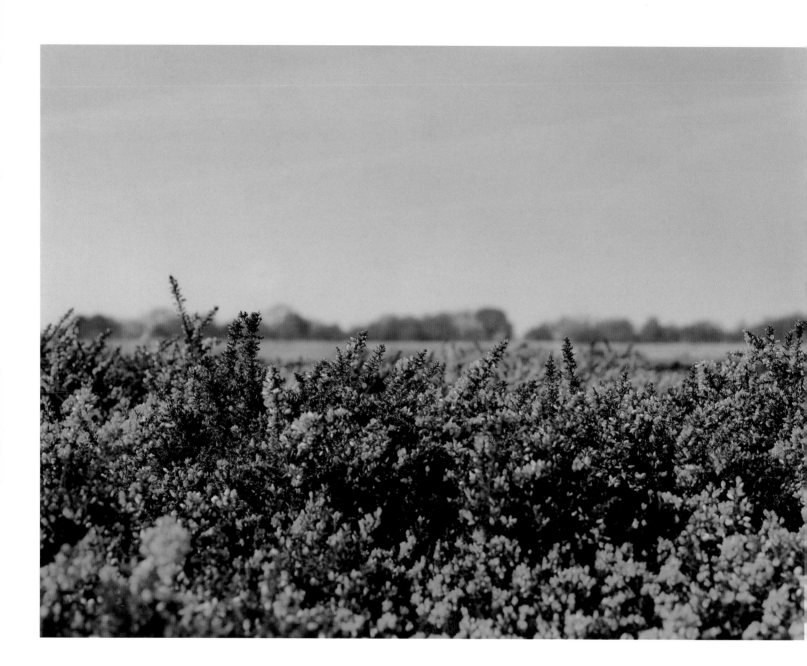

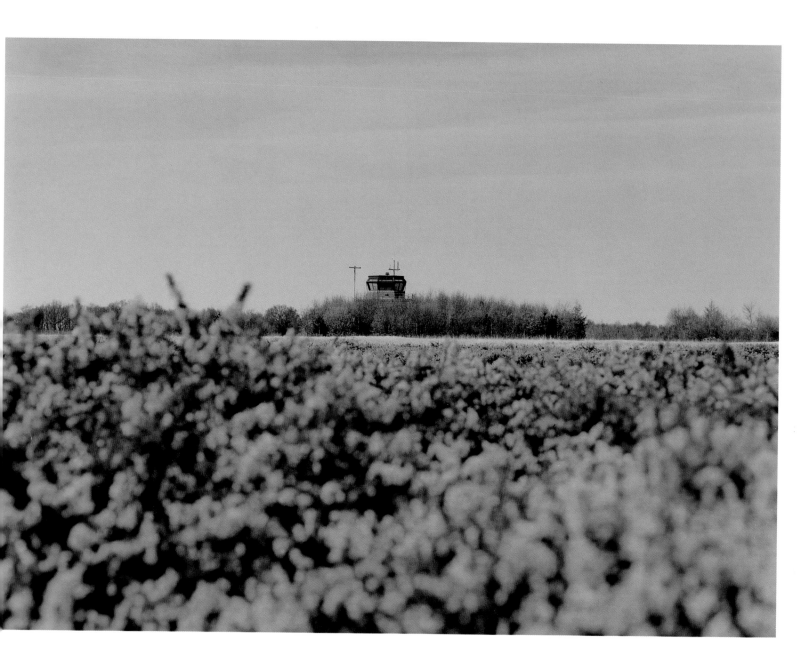

XVII

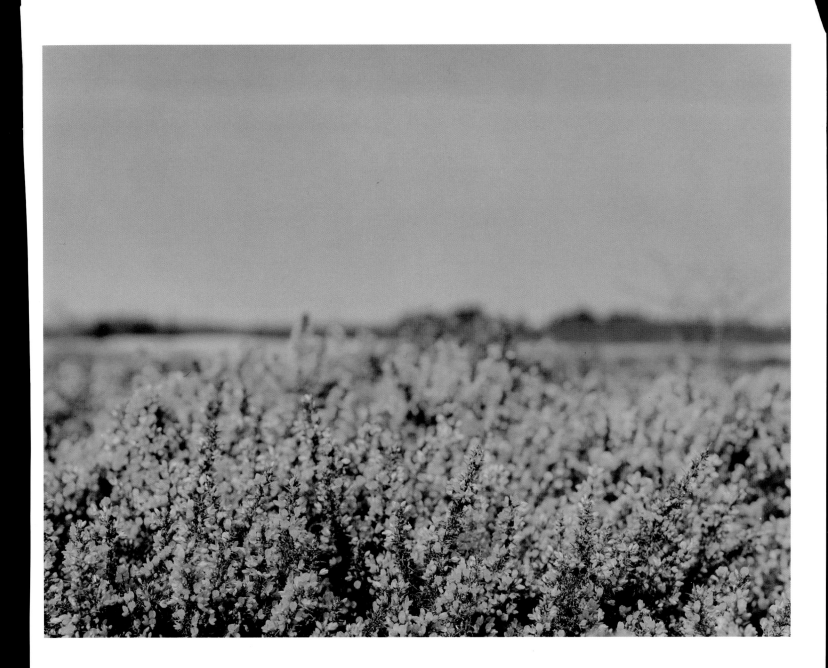

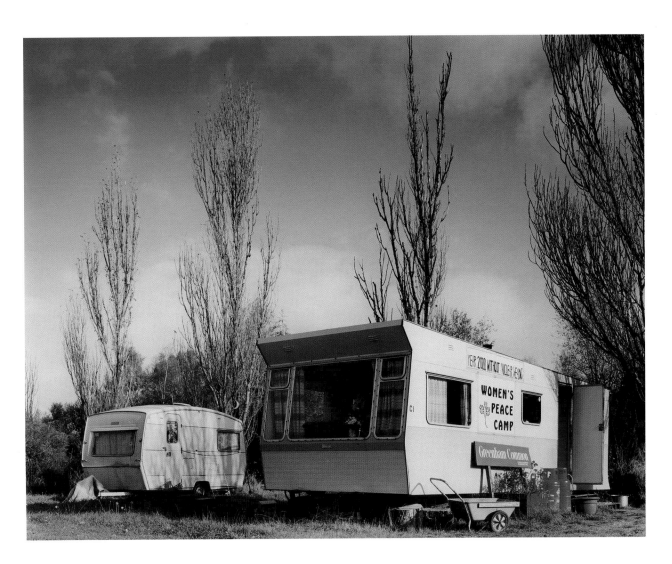

XVIII

XIX

XX

XXI

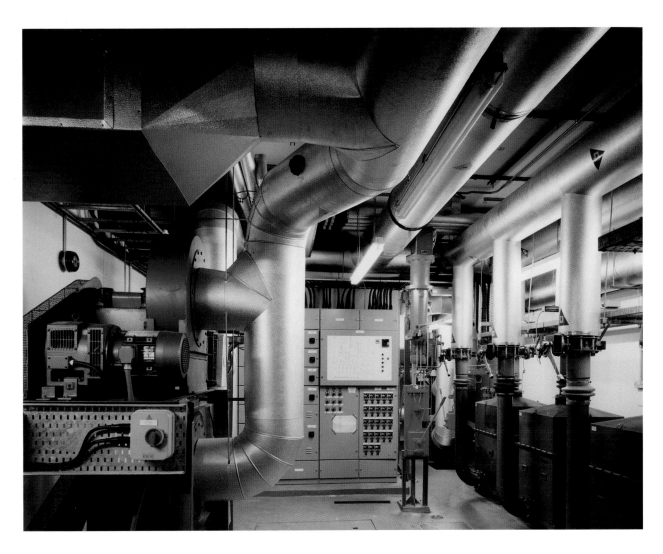

XXII

XXIII

XXIV

XXV

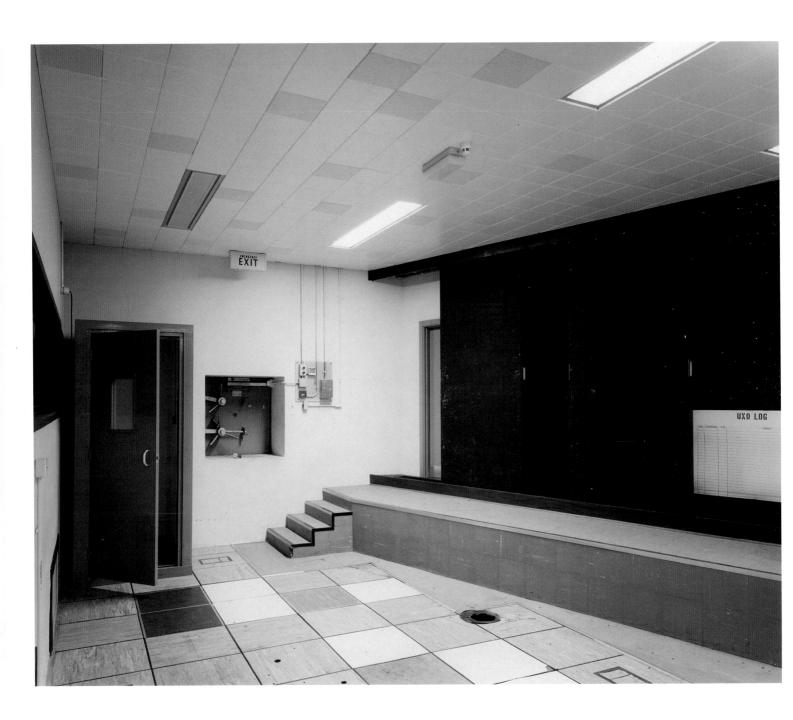

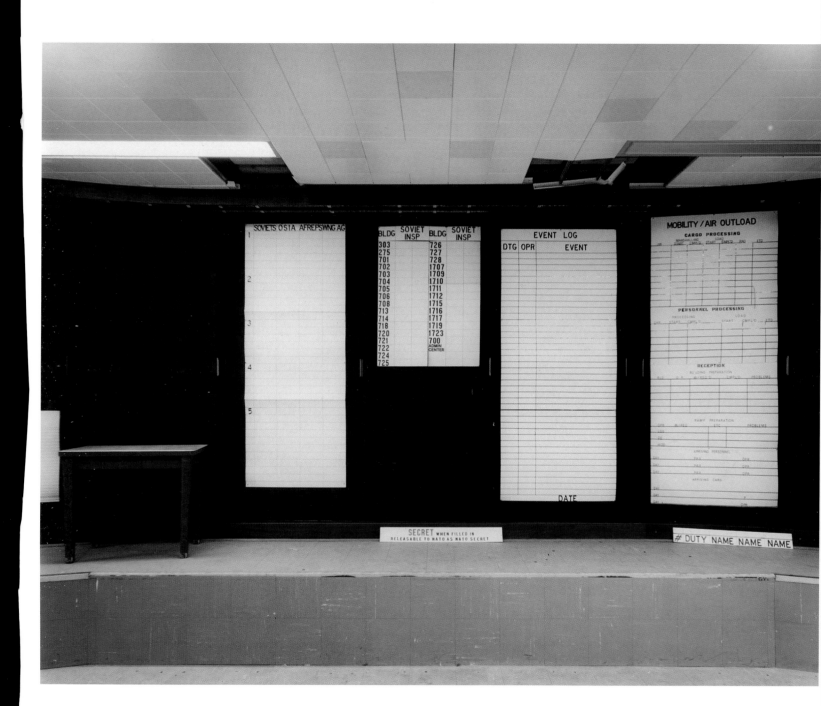

XXVI

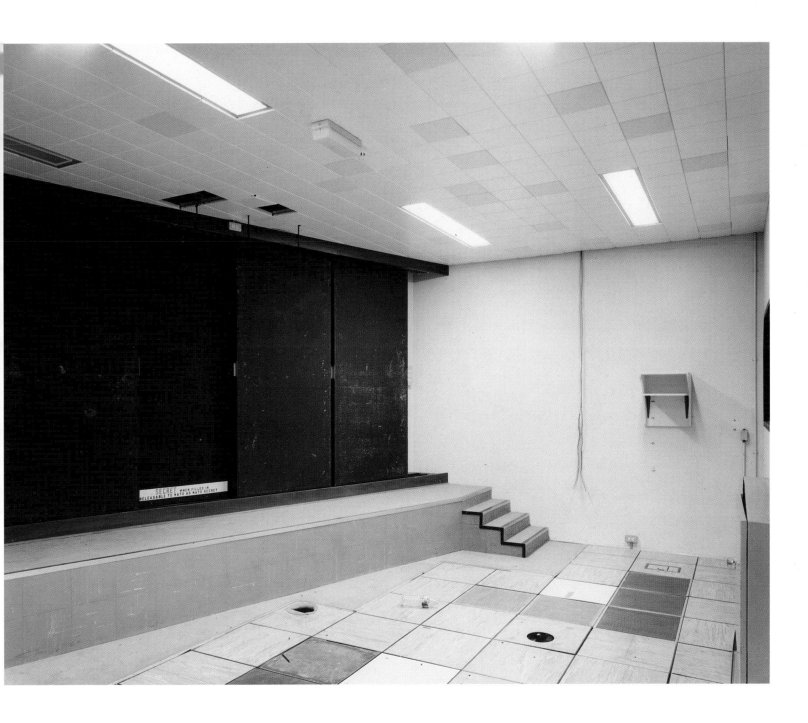

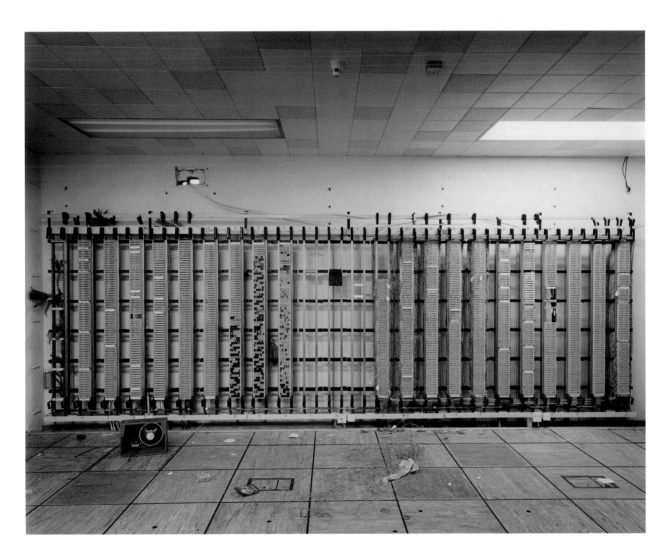

XXVII

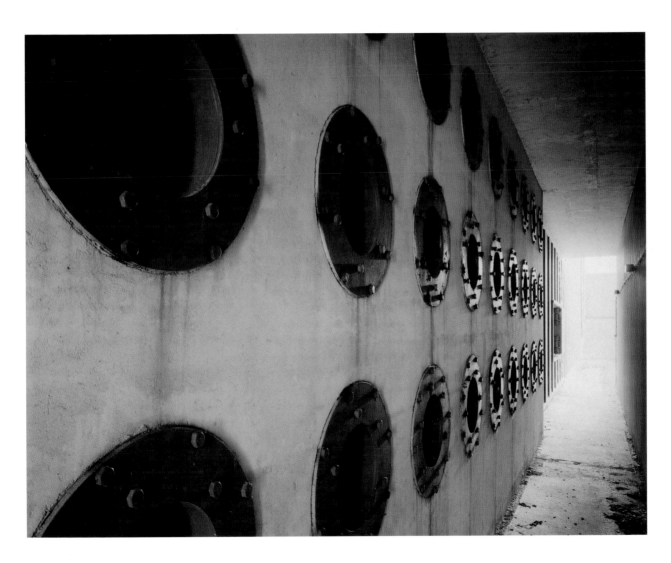

XXVIII

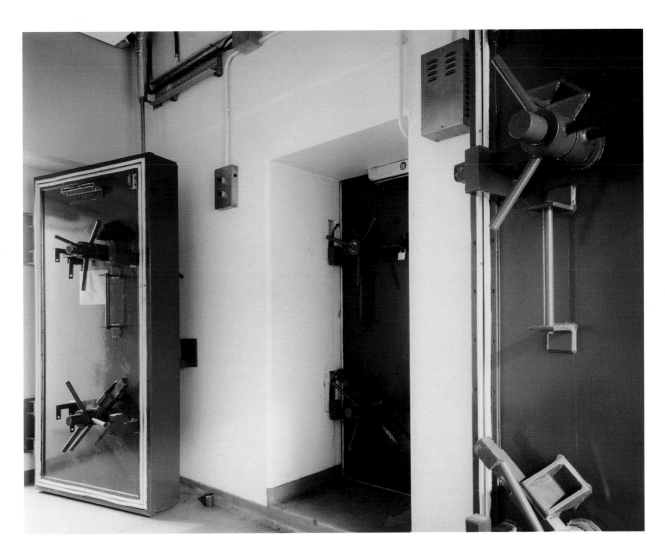

XXIX

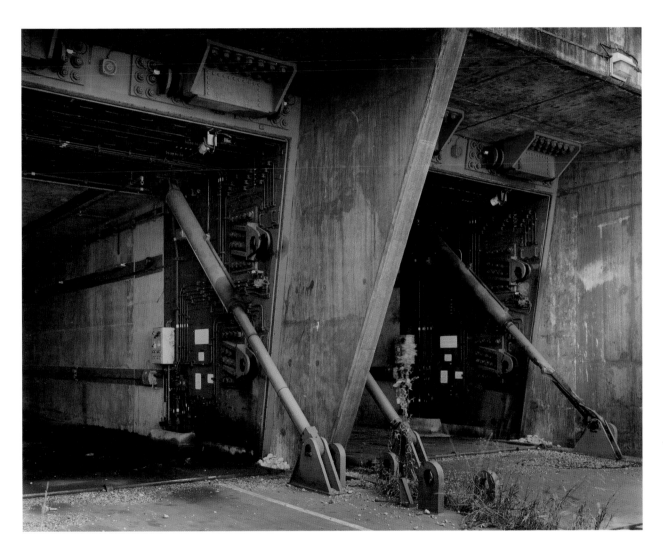

XXX

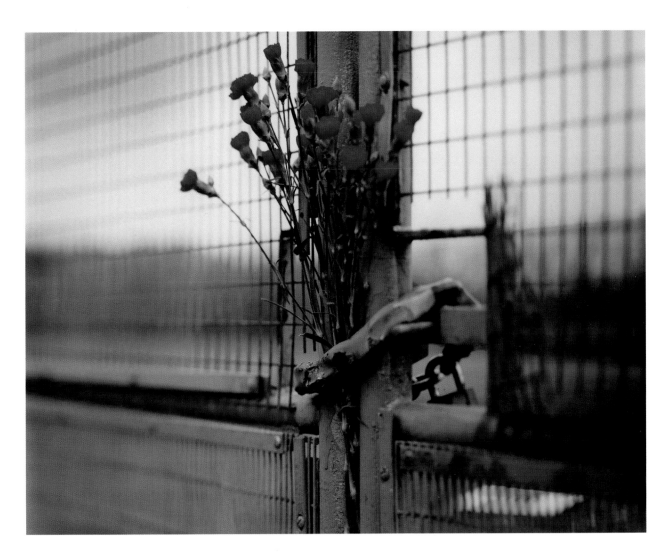

XXXI

POST COLD WAR LANDSCAPE:
AN ELEGIAC DOCUMENTARY MARK DURDEN

John Kippin's beautiful large format colour pictures are fascinating precisely because they make manifest the tensions and contradictions which underlie our experience of the contemporary landscape. While his pictures make allusions to the codes and conventions of landscape painting, the concern is not overridingly with form and art history. Working within a documentary tradition, Kippin's landscapes are defined in relation to particular social and political realities. His recent project at Greenham Common sets a pastoral idyll historically associated with a sense of Englishness against the remnants of a US military base. This series of 32 pictures uses the fears associated with the Cold War past to introduce an element of the sublime into non-sublime beautiful English scenery.

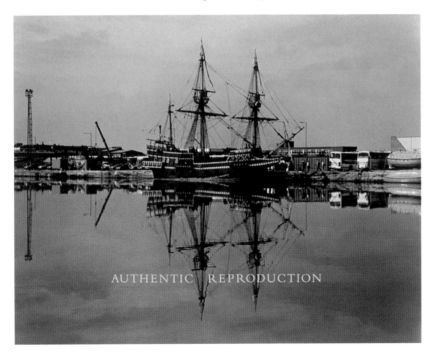

John Kippin, *Authentic Reproduction* (colour original), 1994.

Kippin's photography complicates our view of landscape. His earlier pictures documented the post-industrial landscape of Britain under a Tory government, a landscape of shopping malls, heritage centres and enterprise zones. Here Kippin set up a series of oppositions within individual images. The frontispiece to the

catalogue of such pictures, for example, borrows a trope familiar to both landscape painting and photography – the use of an expanse of water to reflect and enhance the view of nature. Only with this picture, reflection serves to enhance the view of a reconstruction of the Golden Hinde, photographed so it is doubled by reflections in the still waters of the docks in Hull. The oxymoronic text overlaying the picture *Authetic Reproduction* underscores the contradictory nature of this splendid touristic object. The mirrored reflection and reference to reproduction also shows us how photography is itself also caught up in all this. This photo of a replica of Francis Drake's famous ship is one of a number of pictures concerned with the heritage industry, and is best seen as an indictment of the way in which the Tory government used the past for ideological ends. For the Tories heritage was a means of appropriating history, packaging a past bereft of class conflict as a means of stabilising and shoring up a sense of national identity, a palliative used to mask the real economic crises and social divisions that marked the country. Kippin gives us a bigger picture, exposes the vacuity entailed as the industrial past returns as entertainment, as mythology, subject to a touristic and essentially consumerist gaze.

Kippin's landscapes come coded with often contradictory signs. In *Shakespeare Country*, for example, the landscape connotation of Shakespeare's England emblematic of the South is played off against a Northern 'reality' of high rises and general urban neglect. The picture shows us the estate of Newcastle's Byker where the local authority named the streets after characters who appear in Shakespeare's plays. The playwright's head can be made out on the end wall of a terrace in Kippin's picture. Yet the opposition being established is not so straightforward as the class-marked North is itself cliché ridden, signalled through the cobbled road and the detail of a cloth-capped male with whippets.

As the leisure/museum economy expanded under Thatcherism, so the old capital bases in the smokestack industries were broken up. The realities of industrial decline are represented in Kippin's picture of the sunlit ruins of the empty coke works, overwritten with the word FORGOTTEN. With such pictures one does not get the ironic distanciation and critique which marks his pictures of heritage. Kippin appears to lament the loss of the old-scale industries based on class solidarity. The melancholy connected with such pictures also seems particularly significant and meaningful when set against the touristic and consumerist encounter with versions of the past as heritage.

When Kippin's subject matter shifts from a post-industrial to a post Cold War landscape, the romantic sentiment and feeling discernible as an undercurrent in his

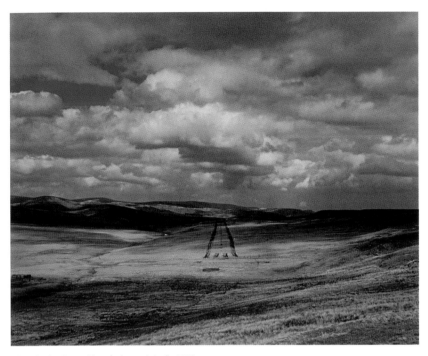

John Kippin, *Target Lines* (colour original), 1992.

previous pictures is less evident. *Cold War Pastoral* makes an elegy and pastoral out of the ruins of the former US air base at Greenham. But of course there is nothing to lament amidst such remains. The last of the 96 ground launch Cruise missiles were flown back to the USA in 1991, eight years after their arrival, and nearly ten years after women began protesting against NATO's decision to site the missiles at RAF Greenham Common. Kippin photographed the site between June 1998 and 1999, when most of the women from the peace protest had left. A year before Kippin embarked on his project, West Berkshire Council had acquired the airbase from the Ministry of Defence and a decision was made to restore the area to a lowland heath and common for use by the local community. Greenham Common is thus pictured at a transitional moment, Kippin is giving us a document of the changing use of this land.

In this series of pictures, evidence of the remains of this base – the empty silos, interior photos of control rooms fortified to withstand a nuclear strike, the remains of what was once the longest runway in Europe – are set within and against the natural beauty of the landscape. Nature here serves a restorative and healing role. What comes across from the photos as a whole is an attention to the setting, the

natural beauty of the Common and heath: the dappling of light through greenery, the yellow gorse, the low angle shot showing the detail of a variety of different wild flowers popping up between the cracks in the concrete runway of the air base. In this respect this work is different to the military scarring Kippin pictured in earlier landscape pictures of the target lines and the ruin of a military plane in Northumberland National Park. If one gets the sense in such earlier pictures of a spoiled pastoral, now what is happening is that the pastoral is covering up military traces.

This sense of recovery and healing is symbolically important. Landscape cushions the horror associated with war. Confronted with the appalling atrocity of genocide in Rwanda, the artist Alfredo Jaar recalled how he sought "three respites from the desperation that surrounded us. We would photograph really horrific scenes, and minutes later, spontaneously we found ourselves taking a picture of the sky, a tree, or a plant". I would not go so far as to see Kippin as a war photographer, but this sense of landscape as antidote and solace is relevant to these pictures.

One should add that the dialectical relationship between war and landscape has a particular history in England. The English pastoral became a central ingredient of patriotism in both World Wars and Kippin is clearly evoking this history in calling his project *Cold War Pastoral*. Part of the problem with photography is the tendency the medium has to freeze and deaden that which it documents. In his post-industrial pictures, Kippin worked against this by setting up a dialectic within the single image and setting many of his scenes beneath beautiful and varied skies. One of the recurring features of these earlier pictures, then, are their skies, influenced by Dutch landscape art and the paintings of such artists as Jacob van Ruisdael and Albert Cuyp.

As David Chandler has noted, such skies set "nature's flux and constant renewal against the sense of permanent damage and irrevocable loss" that underpins much of his work. In *Cold War Pastoral*, he abandons the dialectic of the single image. The dialectical nature of this work is the result of cumulative relations set up between the pictures in series, the tensions and oppositions set up between the remains of the US military base and the richness of its pastoral landscape setting. But a sense of freezing and memorialising events nevertheless remains. Taken in a post Cold War climate, the pictures invite us to look back to this time of protest and nuclear threat. The abandoned military place entails a familiar aesthetic – deserted houses on the air base call upon a long-standing tradition of a photography of empty and emptied out places. Walter Benjamin's famous remark on Eugene Atget's photos being empty like the scene of a crime becomes apposite.

In a sense one can say nothing happened in the spaces Kippin pictured. They remained potential scenes of the crime of genocidal destruction. But in another sense, Kippin's documents draw attention to the fact that something did happen. They are scenes of the crime of the occupation of English land by the US military and the location of their nuclear missiles there.

Kippin's *Cold War Pastoral* invites analogies with Richard Misrach's pictures which evidence the way in which the landscape of the Nevada desert is abused and scarred by military use. He shows us how the US Navy have been using this part of rural America as a bombing range since World War Two. Misrachs' pictures subvert an icon of American identity, show us the desert as a post-apocalyptic landscape, of spent missiles, bullet-ridden targets, craters, toxic pools and dead livestock. However, Kippin's Greenham Common pictures are less violent, quieter, subtle, even local in relation to the grandeur of Misrach's subject.

The womens' civil protest at Greenham very much shapes perception of Greenham Common. Kippin honours this struggle through pictures of the symbolically charged objects which have been attached to the air base's remaining perimeter fencing: a family snapshot, a game bird, red carnations. Such symbolic traces of the womens' protest and the makeshift remains of one of their camps, counterpose the inhuman spaces of the silos and the heavily fortified spaces of the former control room in the US air base, pictures disturbing not only for all the thoughts of US power and fascism the structures might connote, but the awful formal beauty Kippin finds in them. In not disguising or denying the aesthetic interest in his subject matter, he is close to Misrach here.

Kippin has said how at Greenham no merely artistic response seems articulate or adequate to the terrifying reminder of how close we came to catastrophe. I get the sense that the disturbing aura of the place has effected his way of picturing. Compared with his postmodern landscapes of heritage sites and shopping malls, his photography at Greenham is much more neutral, more matter of fact. There is a certain forensic quality to these pictures, a sense of simply gathering evidence, of preserving visual traces before they disappear. Much as one might detect in these pictures Kippin's love of the natural environment, a certain romanticism, at the same time he recognises that the regeneration and reclamation of the former US site as a nature reserve also entails an inevitable process in which history disappears, is covered over. The recovery of land from US occupation might be cause for celebration, but Kippin's pictures do not convey a sense of celebration. Instead they remain rather understated and elegiac, haunted by the horror carried by the lethal weapons which used to be stored at Greenham.

The last image in the series shows red carnations placed against a padlocked gate of the perimeter fence. It is hard not to see the picture as a point of closure. The floral tribute seems to function as a token of remembrance, and to underline the memorialising aspect of Kippin's whole project, to reinstate the irrevocable pastness of his documentary, that we are looking back at something. Yet this should not mean we simply look back from the assumed safety of a post Cold War present at these pictures. Kippin's documenting the traces of what went on at Greenham is ultimately about us not forgetting. And as George W Bush's plans for a vast missile defence threaten an escalation of the arms race, the struggle and protest associated with Greenham is far from over.

PARADOXES OF THE PASTORAL LIZ WELLS

> The Cruise missile makes no noise and the only inconvenience the local
> population will experience is the occasional sight of the missile launchers on
> the roads.[1]

Pastoral imagery is complexly inscribed within Englishness. The myth of England as
a green and pleasant land persists despite increasing urbanisation and, in rural
areas, industrial-scale farming. Like all myths, there is some grounding in reality –
the English landscape is generally relatively green, courtesy of our rather damp
climate and mild northern sun. Indeed, the moisture not only contributes to
keeping vegetation green but also refracts daylight in ways which emphasise this
greenness visually. But myth begs interrogation. What uncertainties or desires may
be reflected? What assumptions or associations are perpetuated, for instance, in
terms of nature, culture and gender? My focus here is upon ways in which the
pictorial may articulate and reinforce romantic – arguably conservative – views of
land and landscape, and upon some of the associated inconsistencies, tensions and
paradoxes.

CONTEMPLATING COUNTRYSIDE:
THE PASTORAL, THE PICTORIAL AND THE PICTURESQUE

Countryside, is a notion which resonates complexly in Britain. Firstly, there are
distinctions between different nations, regions and cities or towns within Britain –
Scotland, Wales, England; Yorkshire, The Highlands, Somerset; Glasgow, London,
Cheltenham. Land has been owned, used and developed differently in various areas
of Britain and images of the landscape and the symbolic sense of its significance in
accordance with specific national or regional consciousness. Secondly, whilst Britain
is a congested island in terms of population, cities, railways, roads, we cling on to
myths associated with a previous rural identity. The burgeoning of concern with
heritage in relation to conservation issues, museums, and tourist attraction, is the
most immediate evidence of this.[2]

Cultural critic, Raymond Williams, suggests that the idea of the countryside
acquired extra significance in Britain in the nineteenth century as the industrial
revolution brought the expansion of cities.[3] He also points out than in English
'country' is an exceptionally powerful term as it signifies both nation and land, both

the whole society or its rural parts. This contrasts with, for instance, French wherein 'la patrie' primarily references patrimony – the male line or fathering, with the addition of the female 'la' to connote fondness/centrality, or with German in which 'heimat' refers primarily to a sense of home. The weight of association between Britain, and the rural, is indicated in this double meaning. To talk of someone being 'in the country' may mean both that they are in Britain and that they are 'out of town'.

This resonance between nation and countryside seems paradoxical since Britain was the first nation to industrialise and, therefore, first experienced the increased urban concentration of population. But arguably it is precisely because of the distance between the everyday experience of city-dwellers and the actual experience of living rurally that allows a mythologised countryside to dominate the nationalistic imagination. Here the power of myth emanates not from misrepresentation so much as from partial representation: some aspects of the rural are regularly imagined (vistas of fields, craggy hills and mountains, villages nestling around Norman churches, snow scenes at Christmas, even romantic mistiness); others rarely figure (silage plants, dead animals, heavy rain, concrete roads including motorways and petrol stations).

'Landscape' as a genre of representation in literature or the visual arts historically, has referenced arcadian ideals of rustic simplicity, spaces wherein nature and culture are organically and harmoniously integrated. As artist-curator John Stathatos notes:

> Arcadia is both place and ideal. The real Arcadia was and remains the barren, land-locked central district of the Peloponnesus, in southern Greece; the Arcadia of the mind was first invented by Virgil and the Roman poets of the golden age, for whom it became the abode of Pan, an idealised landscape of leafy forests and green meadows peopled by nymphs and shepherds at play in an unending summer twilight. Having become a symbol, Arcadia was resuscitated at the Renaissance as a paradigm of idealised nature, uncorrupted and benevolent.[4]

Hence, as is evident in Restoration drama or in the observations of Jane Austen, a complex articulation of attitudes whereby, although country dwellers were seen as less civilised and despised for being less socially adept than city people, urban residents yearn for and romanticise countryside. Hence, also, the incorporation of peaceful 'arcades' – arched openings or recesses – in landscaped gardens. (And, later, the shopping 'arcade' – an ideal space for the pleasures of consumption!)

Arcadia, then, is originally associated with the pastoral. As is implied, the 'pastoral' (once pasture areas for shepherds tending sheep or cattle) came to signify a more complex set of myths relating to beauty and the rural. The Renaissance induced an intensity of attention to natural beauty and nature became an object of scrutiny not only for rural workers but by scientists and tourists, that is, intellectuals.

Thus, Raymond Williams argues, two parallel traditions developed: on the one hand, a concern with detailed mapping and description of the natural through diaries, 'nature' poetry, paintings and sketches. On the other hand, there was a romanticisation of countryside, particularly in aristocratic circles.[5] For instance, *A Midsummer Night's Dream* – first performed sometime before 1598 – offers the archetypical pastoral romance: the lovers seeking and finding each other in the woods, and rustic 'untutored' craftsman getting lost in the mists whilst rehearsing a play to be performed as service to the fairy king and queen; an idealised fantasy rural idyll within which cheeky spirits may roam 'over hill, over dale'. These dramas were written as entertainment for the court, offering bucolic fantasy for the aristocrats of the era. Or as art historian, Kenneth Clark, notes:

> We are surrounded with things which we have not made and which have a
> life and structure different from our own: trees, flowers, grasses, rivers, hills,
> clouds. For centuries they have inspired us with curiosity and awe. They
> have been objects of delight. We have recreated them in our imaginations
> to reflect our moods. And we have come to think of them as contributing
> to an idea which we have called nature.[6]

Such pleasures of the imagination became articulated variously, over the centuries, through landscaped parks, paintings and novels, to postcards, cake tins, and, even ceramic shepherdesses.

LANDSCAPE AND ART

Central to the history of landscape painting – and subsequently photography – has been an emphasis upon order and harmony, reflected in pictorial composition as well as in content or subject matter. Landscape as a genre in painting in Northern Europe dates from Flemish painting in the late sixteenth and early seventeenth centuries which took an apparently natural landscape as context for the celebration of windmills, ships, fields, estates, that is, for celebrating the emblems of property

ownership and Dutch mercantile success. The genre developed and became re-articulated within various specific contexts, for instance, the French seventeenth century painter, Claude Lorrain, may be seen as a principal influence, in terms of the idealisation of landscape, whilst, later, the German painter Casper David Friedrich emphasised the monumentality of forests and mountains. Landscape painting in Britain, up until the eighteenth century, had been seen as a rather minor genre. The art historian, Ernst Gombrich, notes that many of Gainsborough's pictures of landscape remained as sketches since it was difficult to find buyers. These sketches are not literal drawings drawn from nature; he re-arranged trees and hills into picturesque scenes making 'compositions' designed to evoke a particular mood. Paradoxically, as Marshall McLuhan notes, "an original painter knows, of course, that when the public demands likeness to an object, it generally wants the exact opposite, likeness to the pictorial conventions it is familiar with".[7]

Central here is a desire for the picturesque; literally, that deemed suitable to be put into a picture. Defining picturesque, photography historian, Margaret Harker notes "emphasis on acute observations and appreciation of scenery; an understanding of proportion and perspective in landscape; and the conception of architecture at one with its natural environment (not to be considered in isolation)".[8]

British land is managed, there is no natural wilderness. It follows that vistas or landscapes are constructed which means that a sense of aesthetic principles, as well as social mores, are in play. This is most particularly evident in the taste for landscape gardening which developed in the eighteenth century. Picturesqueness became associated not only with a way of thinking about what we see, but also with a set of design principles whereby vistas in the gardens and parks became constructed specifically to designate views and spots from which to view, providing a central vantage point for the individual viewer.[9]

As can be seen from visiting many of the houses now managed by organisations like The National Trust and English Heritage, the eighteenth century country house became a place from which to look, as well as within which to live and entertain.[10] Country houses adopted grand style. Where previously they had been located in valleys, taking advantage of shelter and running water (streams), now they were built on hills in order to take advantage of the views. It then followed that the views were shaped by landscape gardeners in accordance with pre-conceived idealised vistas. Increasingly the emphasis was less upon land as a working environment (although it continued to be so) and more upon landscape as a prospect for contemplation. Such picturesque notions continue to be 'written into' everyday experience: for

instance, road travel or walks through the British countryside include picnic areas just off the road in 'beauty spots', and road signs invite us to stop at 'viewpoints' over particular hills and valleys, offered not only as scenery but also as designated photo opportunities. We, as tourists, are encouraged to look and take pictures simultaneously as observers both of landscape and of traditional aesthetic conventions.

Class, territoriality, and the particular characteristics of the English countryside feature within traditional landscape. As John Berger has argued in relation to Gainsborough's portrayal of Mr and Mrs Andrews and their desire to own an oil portrait of themselves with their own land in the background, "among the pleasures their portrait gave to Mr and Mrs Andrews was the pleasure of seeing themselves depicted as landowners and this pleasure was enhanced by the ability of oil paint to render their land in all its substantiality".[11]

Mr Andrews stands, gun tucked under arm, whilst Mrs Andrews sits, posed and poised. The dog is by Mr Andrews, reminding us of his role as hunter/gatherer/entrepreneur. The vista stretching into the distance is empty of other humans. It is theirs. Social class, land rights, gender distinctions and entrepreneurial success are articulated through this image. Likewise, the Victorian Pre-Raphaelite Ford Madox Brown painted *The Pretty Baa Lambs* in which he depicted a woman holding a baby amongst lambs in the pastures whilst a further woman on her knees harvests produce from the fields. Here the women pose as a part of this ostensibly natural scene; the women and baby visually associated with the innocence of the lambs.

Furthermore, in the idealised landscape, hard labour rarely appears to take place. Land is simply 'naturally' there. If noted, it is synthesised compositionally within the landscape – rather than attention being drawn to the rigours of rural work.

> ... human creation and nature so inter-penetrate in our understanding that they apparently preclude the likelihood of producing clear conceptual distinctions. Human beings are a fragment of nature, and nature is a figment of humanity. Similarly, the painterly and representational perspective that landscape ordinarily connotes, that determines the natural 'prospect' loses its authority when ascribed to the work of the artist's imagination. It suggests, instead, a concern with constructing landscapes, both on canvas (or film) and in the land itself. Prospects in representations depend on the artists' imaginative construction and, in reality, look out onto land whose cultivation requires labourers, artisans, animals, tools, and a whole aesthetic, economic, and social order.[12]

The emphasis is upon nature as bountiful, on agrarian plenitude. Film and photography, likewise implicated in picturing the rural, draw upon established pictorial conventions in terms of theme, subject matter, framing and composition. Landscape photography inherited formal devices in terms of the organisation of the image, use of colour, and the centralised viewing position whilst bringing into play photographic codes such as focus, depth of field, harshness or softness of light, and colour or tonal contrast, to lend extra emphasis.

Photographs also draw attention to detail: in principle, the camera records everything within the view in a non-selective fashion; the camera 'traces' or 'stencils' an image based on what is actually in front of it, regardless of whether or not specific items were noticed by the photographer at the moment of making the image. Photographs thus seem to offer in*sight*. Yet, as Susan Sontag has argued, photographs give us an *unearned* sense of familiarity with and understanding of a world which we consume in a mediated fashion, through images.[13]

At the same time, through their inscription within ideological currencies, photographs contribute to soliciting particular understandings and responses to places and circumstances depicted. Hence a continuing need to be alert to the *politics* of representation. Perhaps the most famous English landscape painter, Constable, offered a number of rural studies, often repeating paintings of the same subject (for instance, Salisbury Cathedral seen from a number of viewpoints). He remarked that: "By a close observation of nature (the artist) discovers qualities which have never been portrayed before".[14]

Here we see a distinctly different emphasis from that of his (more or less) contemporary, Turner, whose poetic interpretations and sublime themes are intentionally 'dis-orderly'. Constable emphasised detailed looking in order to *see*. In this respect we can credit him as a forerunner of *photographic* seeing. He dismissed picturesque set pieces which observed traditional aesthetic rules of colour, composition, etc.. As the story goes, a friend once told him off for not giving his foreground the requisite brown of an old violin; Constable put a violin on the grass to demonstrate the difference between the fresh green of English grass and the warm tones expected by convention. Here, of course, the conventions had been influenced by French and Italian artists drawing upon Mediterranean colours; Constable's radicalism lay in his insistence on looking at the English landscape. It is this that we see, for instance, in his well known 1821 picture of *The Hay Wain* which not only hangs prominently in the National Gallery, London, but is also widely reproduced in books and as postcards.

Peter Kennard, *Hay Wain with Cruise Missiles* (photomontage), 1981.

THE PASTORAL:
CHALLENGED YET REAFFIRMED

Although radical in his time, the work of Constable has now come to epitomise English landscape painting and, by extension, Englishness. Photographer, Peter Kennard, created a number of memorable images for Campaign for Nuclear Disarmament (CND) campaigns. In one of his best known photomontages, which appeared both in colour and in black and white, on postcards and posters, he inserted Cruise missiles into *The Hay Wain* emphasising the threat to the countryside – and, by extension, to the country as nation. The figures in the cart wear a helmet and a gas mask, by contrast with the hats worn by the rural workers depicted in the original. Here the Constable painting stands as an emblem of the rural and rustic, now under threat from international militarism. Nuclear destruction is, in itself, invisible; smooth metallic cruising missiles – which, as *The Daily Telegraph* told us, might occasionally be spotted travelling by road – are its only immediate visible manifestation. Development of the road system, automobiles, motorways for purposeful driving, and the extension of car ownership were key twentieth century phenomena, machinery produced through assembly line manufacturing techniques; both the machine and the system associated with

progress. Cars are also associated with the masculine – with advertising largely targeted at male buyers as fathers, sports car dilettantes, surfers with jeeps, or whatever.

Here, in the photomontage, the missiles travel not by road but sit in the traditional hay cart which, by contrast with the car, appears conventional, unthreatening, feminised. The missiles, central within this image – the painting itself and all that is associated with it – threaten this tranquillity. The primary rhetorical point of the montage is to point out that Cruise missiles are amongst us, turning us into an American military base and, therefore, into a target. The point is clear, although, paradoxically, it is made through reinforcing the stereotype of the rural idyll. One response might be that we are all being invited to turn ourselves into Little Englanders, agitated both by the presence of the Americans and by the threat to that which we now take as archetypically picturesque. The circulation of the photomontage as posters and postcards further contributes to its association with an imaginary pictorial as it took its place in relation to the repertoire of selective representations of the rural which constitutes postcard culture.

GENDER AND THE PASTORAL

As the American artist, Barbara Kruger, proclaimed in one of her more famous photomontages "we will not play nature to your culture". Yet Greenham, paradoxically, appears to do exactly that! The Peace Camp was established and run by women evidently living close to nature (tents, caravans, etc.). The purpose was to maintain protest against masculine militarism. Mechanisation, which, at the beginning of the twentieth century, so fascinated the Futurists, with their idealisation of the mechanical as progress, may be associated with the masculine. If we construct a binary in terms of gender, then conservation comes to be associated with the feminine, by extension linked with the natural, the domestic, and the compassionate.[15]

In her series *Groundings* Sian Bonnell draws attention to the extent to which the rural is referenced in the domestic. Biscuit cutters, oven gloves and tea towels, china and ceramics regularly feature pastoral shapes and garden images, reminding us of the natural source of foods but also romanticising this, by extension obscuring the global mass-scale industry involved in supplying supermarkets. Here she pictures the cutter used to shape sandwiches for her children back in its 'rightful' place with the other sheep in the Dorset fields through which she used to walk twice weekly in 1996 during the Gulf War when, if the wind was in a certain direction,

Sian Bonnell, *Fell* (from the series *Groundings*), 1996

she could also hear the noise of the shooting range and helicopters taking off and landing at Lulworth (military) air base nearby. As with Peter Kennard's picture, this drawing attention to the linking of domestic and pastoral has the effect of reinforcing the pictorial in that the hills fall evenly across the picture and the sheep graze with apparent contentment, although the use of black and white and the relatively dark print might be taken to indicate a certain foreboding.

GREENHAM RE-VIEWED

Greenham Common is located in what might be seen as an 'in-between' area, not that far from London, near enough to house a number of aristocratic 'country' retreats, now heritage sites for day trippers. By contrast with the Celtic areas (Scotland, Wales, Cornwall) or the moorlands of the North and West (Yorkshire, Devon, the Lake District) it lies in an area long since 'tamed' and fenced into use for new towns as well as animal and crop farming. In this context the Common was – and should have remained – 'common land'. Yet typically, a glance at the map for Berkshire indicates the persistence of reference to – desire for – the rural past,

despite the network of road and rail that criss-crosses the county; Greenham (as in hamlet) is near to villages such as Bishop's Green, Crookham and Goldfinch Bottom as well as Newtown, and Newbury.

For my generation, CND, and perhaps more particularly, the Peace Camp at Greenham Common, stand as icons of resistance within the Cold War, intensified through the nuclear arms race with its threat of mass destruction. Greenham was, of course, a struggle led by women, a Peace Camp reliant on those prepared to give up a whole period of their life in the cause of protest, supported by many who fund-raised, visited, relayed food and provisions, and so on. The Womens' Camp and a number of specific peaceful mass protests, for instance, ringing and singing around the perimeter of the US base, came to stand for resistance in a number of ways which included, first, resistance to Britain being incorporated as the '51st State' to be used as a missile launch pad, with all the immediate attendant risks of extinction of people and places. The American military once again was over here, and, for many, not in the least bit welcome. Secondly, women from a diversity of groups and political positions united as pacifists. Thirdly, as indicated in the Kennard photomontage, there was commitment to the defence of 'our' countryside, with its complex ecological balance and its proper agrarian or recreational uses, albeit viewed to some extent in arcadian terms. Fourth, there were broader concerns about industrial pollution, nuclear fall-out, and the risks of man-made environmental disaster. Finally, Greenham came to stand for the moral role of women as agents of protest albeit, paradoxically, also symbolising an elemental affiliation of the feminine with the natural, one over which feminist movements of the time were divided intuitively, politically and intellectually.

John Kippin's photographs of Greenham remark details of the now abandoned space, views from the Common no longer interrupted by the 'occasional sight' of missile launchers. At one level we are reminded not to forget the tensions and uncertainties of the threat of nuclear war. He invites us to consider ways in which the legacy of the American occupation of the Common remains marked in the landscape, for instance, in the binocular effect of disused driveways across the site.

Simultaneously, he notes ways in which, visually, the impositions of military presence are being softened and literally incorporated into the heath land. Through offering us the opportunity to look close up, these photographs invite us to consider detail of the sort which we might overlook when actually visiting particular locations. Our attention is drawn to the organic: weeds grow in the cracks of the tarmac, bushes embrace wire fences and rusting metal objects. We also note

architectural change as the woods draw elements such as the tall metal posts supporting security lamps, linked as if a pathway through the autumnal colours of the trees, into the landscape.

Yet the symbols of military presence remain in the signs alerting one to the dangers of razor wire or barbed wire and excluding all but 'authorised personnel' as does the history of the protest marked, tellingly, by womens' symbols on concrete posts. But the work transcends the particularity of location. We are reminded not only of the recent history but of the complex relation of culture and nature wherein emblems of habitation may become absorbed, rather as spring growth may obscure dead wood. The notional binaries of urban and pastoral, civilisation and bucolic, masculine and feminine, military and peace, nature and culture refold and reform in a complex manner.

AND NOW...

I write at a moment when the British countryside is 'closed down' (to use the phrase oft repeated in the media in February/March 2001) due to foot and mouth disease, which is impacting upon the economy and upon the lives of those who live rurally. Like nuclear annihilation (chemical), an invisible enemy (virus) carries an all too real threat. Footpaths and bridle paths are closed, our right to roam curtailed as public rights of way through and across the generally privately owned farmlands of Britain have become forbidden territory. The animals which normally figure in the picturesque views of farmlands and estates are being slaughtered in thousands, not in the regular pursuit of meat production, but in an attempt to curb a disease which, whilst not a killer of humans or livestock, is deadly in terms of international agricultural trade agreements.

Tourism, one of the mainstays of the British economy, is in crisis as a consequence. Rural heritage and leisure industries operate through mythologising the countryside, re-inventing images of idealised past landscapes and lifestyles, and drawing a veil over the economic and everyday practicalities of maintaining moorlands, pastures and wildlife. As with the fight over Greenham, once again we are confronted with uncomfortable home truths which undermine the more romantic pastoral imaginary. The struggle over Greenham was primarily political, with passive resistance at its heart. But it also brought into focus questions of representation and many of the associated myths and paradoxes of the pastoral.

NOTES

1. *Daily Telegraph* 31.10.79, quoted by Peter Kennard, *Camerawork*, No.19, July 1980.

2. Robert Hewison has pointed out that in the1980s on average one new museum opened in Britain every fortnight. Hewison, Robert, *The Heritage Industry*, London: Methuen, 1987.

3. See, in particular, Williams, Raymond, *The Country and the City*, London: Chatto & Windus, 1973.

4. Stathatos, John, *Fleeting Arcadias* (catalogue for South Bank touring exhibition), 1999.

5. Williams notes, for instance, that shepherds, nymphs and other woodland beings figured in aristocratic entertainment and pastoral dramas deploying, for instance, the shepherd as an 'innocent' figure through whom love and sexual intrigue can be elaborated.

6. Clark, Kenneth, *Landscape into Art*, London: John Murray, 1979 (originally publishished 1949), p. 1.

7. McLuhan, Marshall and Eric, *The Laws of Media*, Toronto: University of Toronto Press, 1988.

8. Harker, Margaret, *The Linked Ring: The Succession Movement in Photography in Britain 1892–1910*, London: Heinemann, 1979, p. 27.

9. Also in pictures: dating from the early Renaissance, perspective in painting is organised around a 'vanishing point', usually a central point on a horizon placed in line with the 'golden rule' of thirds whereby the landscape image is composed of one third sky and two thirds land (or sometimes *vice versa*).

10. The work of Italian architect, Palladio, was a key influence. See, for instance, Chiswick House in West London, designed in Palladian style about 1725; or Stourhead in Wiltshire, where the gardens were developed circa 1741. Eighteenth century landscape gardeners acquired status and reputation, for instance, Capability Brown and Humphrey Repton.

11. Berger, John, *Ways of Seeing*, Harmondsworth: Penguin 1972, p. 108.

12. Kemel, Salim and Ivan Gaskell, eds., *Landscape, Natural Beauty and the Arts*, Cambridge: Cambridge University Press, 1995.

13. Sontag, Susan, *On Photography*, Harmondsworth: Penguin, 1979.

14. Pevsner, Nikolaus, *The Englishness of English Art*, Harmondsworth: Penguin, 1993 (first published in 1956), p. 158.

15. Of course, the mass destruction of World War One in Europe drew attention to the paradoxes of Futurism, as movement and ideal, with its emphasis on the potential of the machine.

THE AUTHORS

Ed Cooper trained as an engineer at Swansea University. After working in the agricultural and construction industries he graduated in conservation management. He later established a countryside project in the Pang Valley, Berkshire and was subsequently employed as the Pang Valley Countryside Project Officer. Cooper is currently employed by West Berkshire Council and was the Environmental Project Officer responsible for Greenham and Crookham Commons.

Sarah Hipperson entered the nursing profession in 1946 and qualified as a State Registered Nurse (SRN) and State Registered Midwife (SCM). She spent three years as a magistrate in the mid-70s and in the 80s started to work on peace issues at local grassroots level. Hipperson was a founder member of the London based Catholic Peace Action. In March 1983 she joined the Womens' Peace Camp on Greenham Common and remained committed to the work of non-violent direct action until its closure on 5 September 2000. As a result of this work she was obliged to spend time in Her Majesty's Prisons. Hipperson has contributed to *Greenham Common – Womens' Peace Camp: A History of Non-Violent Resistance 1984–1995*, by Beth Junor, with illustrations by Katrina Howes and *The Penguin Book of the Twentieth Century PROTEST*, edited by Brian McArthur. She has also contributed to the sound archive at the The Imperial War Museum, London.

John Kippin is an artist and photographer who lives and works in the North East of England. He has exhibited and published his work widely throughout the UK as well as in Europe, America and Asia. He has worked on a number of public art projects and contributed to numerous conferences and journals. Kippin is currently employed as a Reader in Photography and Digital Imaging at the University of Sunderland.

Mark Durden teaches the history and theory of photography at the University of Derby. He is part of the artist group *Common Culture*. Durden recently co-edited *Face On: Photography as Social Exchange*, Black Dog Publishing, 2001.

Liz Wells is a writer, curator and lecturer. She has published widely on photography, including: *Photography: A Critical Introduction*, London: Routledge, 1997/2000; *Viewfindings: Women Photographers, Landscape and Environment*, Tiverton: Available Light, 1994 (also a touring exhibition 1994/1995). She co-edited *Shifting Horizons, Women's Landscape Photography Now*, London: I B Tauris, 2000 and co-curated the accompanying exhibition. Wells is currently working on *The Photo Reader,* for Routledge, and on a series of essays on landscape. She lives and works in Devon and is a Senior Lecturer in Media Arts at the University of Plymouth.

ACKNOWLEDGEMENTS

In addition to those that I have already mentioned in my introduction I would also like to thank Katrina Howes and Jean Huchinson who made me so welcome at Yellow Gate during the period of my stay on Greenham Common; Dominic Parrette and Mark Hampton, Countryside Wardens at Greenham and Crookham for their support and assistance; Alan Wilson of Redline Books, Newcastle upon Tyne for his professional design and publishing skills and advice. Paul Smith of Index Print, Newcastle upon Tyne for his valued design and technical skills; Duncan McCorquodale for his editorial vision and making this publication happen; Angela Weight, Curator at the Imperial War Museum in London for her encouragement in accomodating and developing the exhibition *SSSI Greenham Common*; Clive Gillman, for his excellent technical advice and support; John Laidler, Director, and Graham Robb, Printer, of Trichrome, Newcastle upon Tyne for their inestimable photographic skills. To Paul Gallagher and Clare Turner of Gallagher and Turner, Picture Framers of Newcastle upon Tyne. To Arabella Plouviez and James Hutchinson from the University of Sunderland and to my other colleagues at the University for their support. Also to my partner, Helen Kippin. To all of the above, thank you.

I would also like to gratefully acknowledge the financial support and encouragement from **West Berkshire Council**, **Northern Arts**, **The Arts Council of England** and the **University of Sunderland**.

COLD WAR PASTORAL: GREENHAM COMMON
John Kippin with essays by Ed Cooper, Sarah Hipperson, Mark Durden and Liz Wells

Design Redline Books, Newcastle upon Tyne

Printed in the European Union.

ISBN 1 901033 97 X

British Library cataloguing-in-publication data. A catalogue record for this book is available from The British Library.

Black Dog Publishing Limited 5 Ravenscroft Street, London E2 7SH, UK. t 44 020 7613 1922 f 44 020 7613 1944 e info@bdp.demon.co.uk